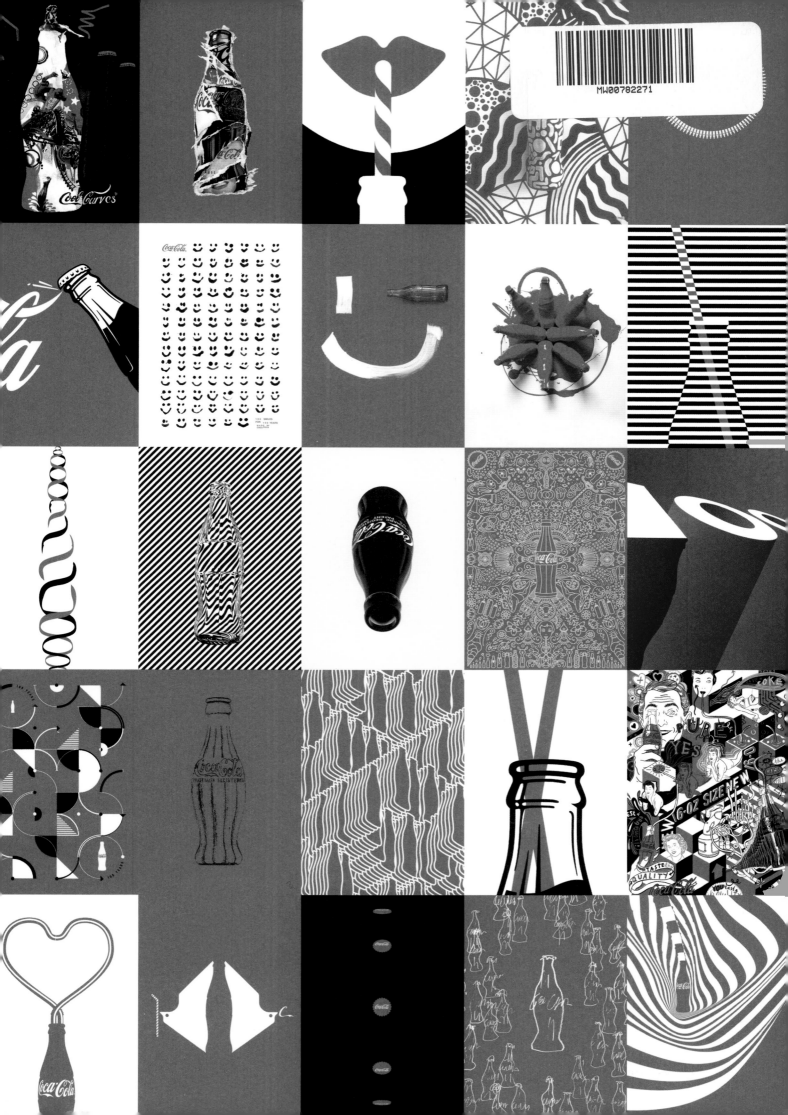

Coca-Cola

KISS
THE PAST
HELLO

100 YEARS OF THE COCA-COLA BOTTLE

ASSOULINE

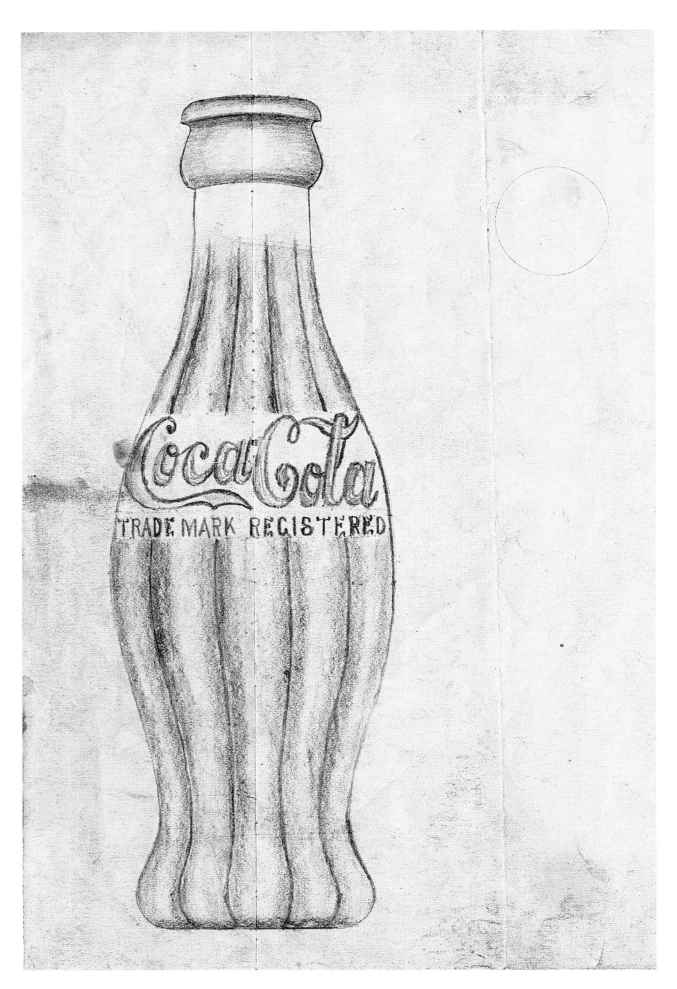

Original sketch of the Root Bottle by Earl R. Dean, 1915.

KISS
THE PAST
HELLO

100 YEARS OF THE COCA-COLA BOTTLE

ASSOULINE

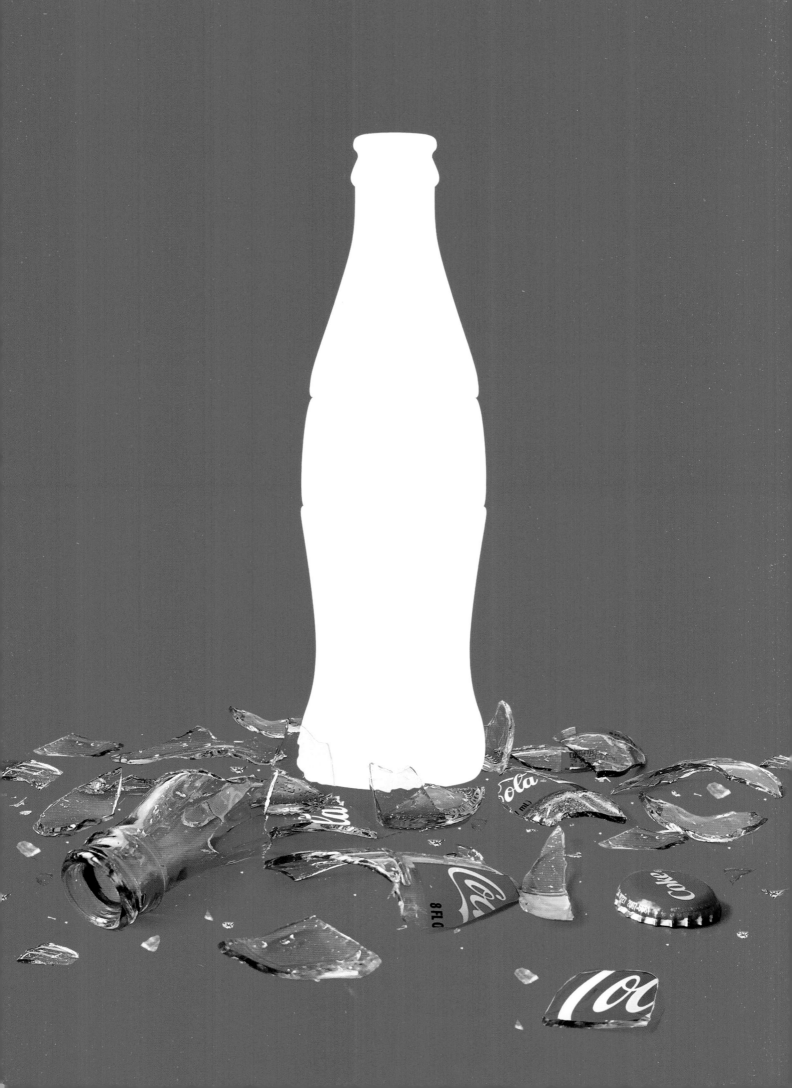

FOREWORD

By Stephen Bayley

It takes time to become a classic.

In a hundred years, the Coca-Cola bottle has been imitated but never bettered. It has inspired the automobile industry, fashion designers, and, of course, artists—not to mention the global constituency of consumers who see in its distinctive profile a reliable promise of pleasure. Democratized luxury is certainly one of the modern world's great achievements. Within the company, the bottle has been a continuous source of business stimulus inspiring new packaging and branding initiatives while remaining essentially unchanged.

I am often asked to define the familiar if overused term "design classic." That's when I reach for the Coca-Cola bottle, as billions, in their different ways, have done before me. It is an ordinary thing extraordinarily well done—immediately recognizable but never boring. It tells a story. It has value, charm, and personality. People enjoy it. In short, it works. Like all great "design classics," whether it be a food processor, a chair, or a pen, the Coca-Cola bottle transcends the limits of its genre and becomes an everyday item imbued with magic.

No doubt, genius and luck played a part in its creation. So too did circumstances. In 1915, the United States needed heraldry to unite a disparate and itinerant population: This was the year D.W. Griffiths released *The Birth of a Nation* and Coca-Cola became a part of American identity. The story of the bottle's origin, with its muddled whole truths and bold half-truths, now has the character of a creation myth, but that only serves to reinforce its classic status.

Turner Duckworth, *Stubborn Optimism*, 2014.

A design can only ever be as good as the brief. And the brief that led to the contour bottle was exceptionally clever. The demand for a bottle you can recognize in the dark was inspirational: In a "design classic" simple inspirations lead to exceptional results. Researching what the bottle's designers thought to be key constituents, the coca leaf and the kola nut, in the 11th edition of the *Encyclopaedia Britannica*—a classic in its own right—led to a design of one of the planet's most familiar and most admired products.

In old Europe, you took refreshment at a café, usually sitting at a table with your beverage in a cup or a glass. These circumstances required little concentration or coordination, and leant themselves to leisurely recreation. But a bottle of Coke you could find anywhere—you buy to go and you drink with one hand while on the move. This suggestive dynamic spoke powerfully of America and its restless hedonism.

Artists soon realized the symbolic potential of the contour bottle. At first, respectfully: Norman Rockwell and Haddon Sundblom made charming pictures about the best of times, where a Coca-Cola bottle was almost a religious artifact, preaching a sermon about domestic felicity. Then a more worldly, not to say cynical, generation of painters, including Salvador Dali, Robert Rauschenberg, Eduardo Paolozzi and, of course, Andy Warhol, treated the ubiquitous Coca-Cola bottle with a knowing irony. This irony, however, did not distract from the value, rather it served only to increase the bottle's meanings. These meanings continue to multiply as the contour bottle moves into its second century.

There were several other occasions of note in 1915. Franz Kafka published *Metamorphosis*, his harrowing novel about modernist dislocation. Henry Ford produced his millionth Model-T, and the neon tube was patented. It was also the year Albert Einstein published one of the key papers in his "General Theory of Relativity," upending the assumptions of physics, just as the Coca-Cola bottle upended the drinks distribution business.

We hear a lot about the Internet and how it will revolutionize the cycle of supply, demand, and consumption. One thing, though, that's never going to be delivered in pixels is a cold drink: best enjoy it in a bottle that is, indisputably, a classic of modern design.

It takes time to become a classic, but then it seems a classic becomes timeless.

Canadian advertisement, published in *Chatelaine* magazine, 1969.

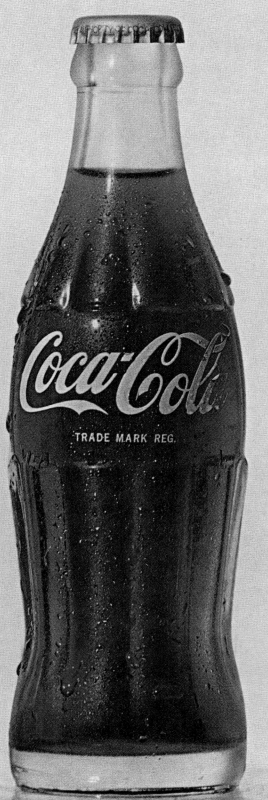
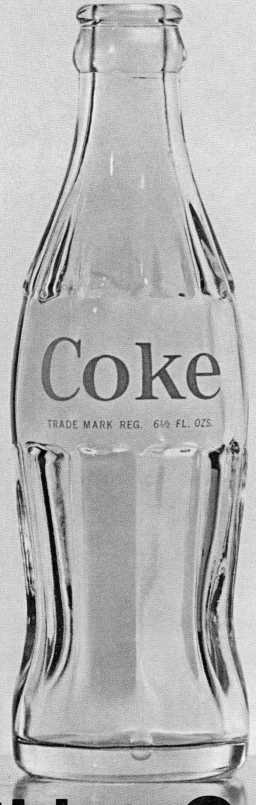

It's the real thing.Coke.
TRADE MARK REG.

The taste of Coke has made it the world's most popular soft drink.
No matter how hard other brands try — nothing else in all the world
tastes exactly like Coke.

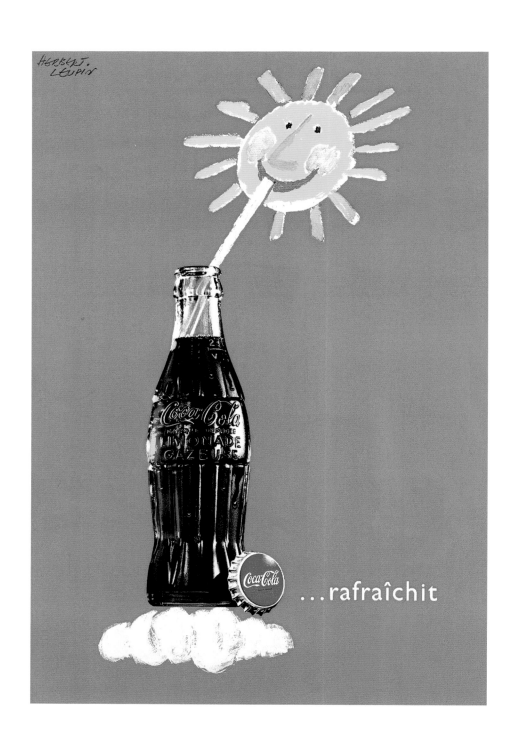

...rafraîchit

Swiss advertisement by Herbert Leupin.
Opposite: James Sommerville, Coca-Cola Design, *Refresh the Sun,* 2014.

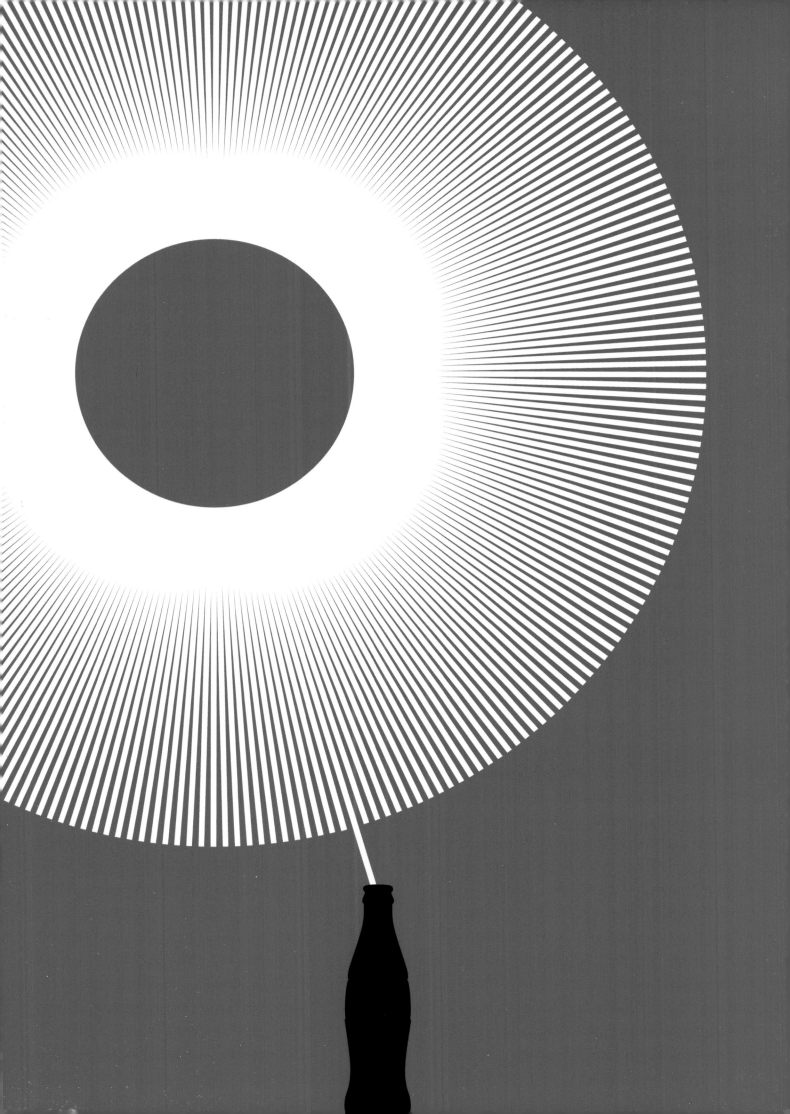

“ What's great about this country is that America started the tradition where the richest consumers buy essentially the same things as the poorest. You can be watching TV and see Coca-Cola, and you know that the President drinks Coke, Liz Taylor drinks Coke, and just think, you can drink Coke, too. A Coke is a Coke and no amount of money can get you a better Coke than the one the bum on the corner is drinking. All the Cokes are the same and all the Cokes are good. Liz Taylor knows it, the President knows it, the bum knows it, and you know it. ”

Andy Warhol
The Philosophy of Andy Warhol (From A to B and Back Again)

Andy Warhol, *Green Coca-Cola Bottles*, 1962; acrylic, screen print, and graphite pencil on canvas, 82 3/4 x 57 1/8 in. (210.2 x 145.1 cm).

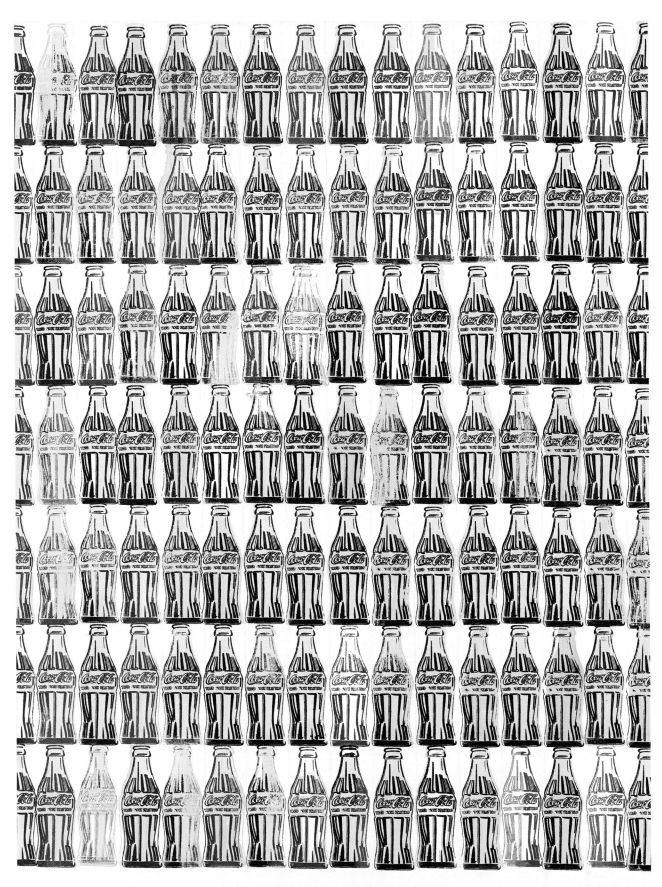

INTRODUCTION

By James Sommerville

I still remember, as a young boy on holiday, being rewarded with an icy Coca-Cola in a curved glass bottle. For me, the sense memory of that cold Coke in my hand is indelibly linked to long summer days, warm sunshine, and the crazy, irrepressible joy of our family trips. A chilled bottle of Coca-Cola may evoke a different remembrance for each of us—perhaps the bright green of a baseball stadium on a crisp autumn afternoon, or gliding to the beach in the back seat of your parents' convertible—but whatever it is, the moment is powerful, evocative, and authentically *yours*. Everyone has their own Coca-Cola memory.

That doesn't happen by chance. When I joined Coca-Cola as head of global design, I paid a visit to the company's archives in Atlanta, Georgia, and was immediately struck by the scope of the brand's history and its unforgettable visual identity. To say that Coca-Cola has done it all from a design perspective is an understatement. But it's not just about logotypes and packaging; Coca-Cola has infused, enhanced, even defined American culture almost since its inception in 1886—everyone from Elvis Presley, Marilyn Monroe, and Jimi Hendrix to Jesse Owens, Gladys Night, Clint Eastwood, Frank Sinatra, and Steve McQueen have been captured enjoying a Coca-Cola from that iconic, contoured glass bottle. Today, the brand's universal appeal has established Coca-Cola as a worldwide symbol for shared moments of joy and refreshment.

Poring over this enormous body of work was equal parts overwhelming and inspirational, and I found myself returning to that famous bottle, with its fluted lines and cascading, organic shape—what noted industrial designer Raymond Loewy described as the "perfect liquid wrapper." As a piece of design it's simultaneously intimate and

universal, personal and popular. But the timelessness of the bottle isn't just born from its perfect interplay of sharp and fluid forms, or its indelible silhouette. As I discovered in the company archives, the contour bottle has for a hundred years represented one very important concept to Coca-Cola customers: a promise.

By 1915, twenty-nine years after Coca-Cola was founded, the drink's distinctive, refreshing character had found nationwide demand—and a host of imitators. To combat these competitors, Coca-Cola Bottling Company members agreed to develop, fund, and support a "distinctive package" for their popular product. The creative brief, sent to eight glass companies across the country, was simple but far from easy: Develop "a bottle so distinct you would recognize it by feel in the dark or lying broken on the ground." In Terre Haute, Indiana, the Root Glass Company went to work and teased the form of a cocoa bean into the delightful shape we know today.

And with it was born a promise: "What you are holding in your hand," the bottle declared, "is genuine Coca-Cola. This is not a lesser product or a fake. It's the real thing."

The design became so popular, so familiar and instantly recognizable that just thirty-three years later, in 1949, a study showed that less than one percent of Americans could not identify the Coca-Cola bottle by shape alone. On April 12, 1961, after all rights to the original silhouette had expired, the U.S. Patent Office declared the bottle's "distinctive contour shape" to be so quintessential, so unmistakable, that the form itself was awarded trademark status.

But by that time the contour bottle had already been stamped in the American consciousness through popular culture and fine art alike. It appeared on the cover of *Time* magazine in 1950, and in the works of sculptor Robert Rauchenberg and painters Salvadore Dali and Sir Edward Paolozzi. By far the most famous portrayal of the Coke bottle remains Andy Warhol's 1962 work "Coca-Cola," the seminal and defining image of the American Pop Art movement. In his 1975 book *The Philosophy of Andy Warhol,* the artist describes Coca-Cola's brand resonance, as represented through that perfect piece of glass:

What's great about this country is that America started the tradition where the richest consumers buy essentially the same things as the poorest. You can be watching TV and see Coca-Cola, and you know that the President drinks Coke, Liz Taylor drinks Coke, and just think, you can drink Coke, too. A Coke is a Coke and no amount of money can get you a better Coke than the one the bum on the corner is drinking. All the Cokes are the same and all the Cokes are good. Liz Taylor knows it, the President knows it, the bum knows it, and you know it.

Amazingly, the shape remains relevant even today, a full century on. Just as the silhouette and size morphed subtly over time—sometimes squatter, sometimes leaner or taller, growing from 6.5 ounces to 8-, 10-, and 12-ounce containers—the more contemporary takes on the contour shape have made use of modern materials and techniques. The 20-ounce bottle made of recyclable PET plastic was introduced in 1993, while an inventive "contour can" was released in limited editions in 1997. In 2008, the Coca-Cola aluminum bottle, a reimagining of Coca-Cola packaging as innovative and refreshing as the original, was awarded the first ever Design Grand Prix at the prestigious Cannes Lions.

And while the Coca-Cola bottle has been brought into the modern era, I still believe that many of our design solutions of tomorrow will be inspired by the original glass Coca-Cola bottle. That's why, in 2014, Coca-Cola Design reached out to creative minds across the globe and invited them to imagine the future of the Coca-Cola bottle experience. The brief for our Icon + Mashup project was, in a nod to our past, simple but far from easy: to embody universal happiness and stubborn optimism, the key messages of Coca-Cola, while helping us imagine the next hundred years of the contour experience.

The results were beyond our wildest expectations, an astonishing compendium of vision and wit. It's an old saying that in good design, form follows function, but with these myriad approaches, everything from Turner Duckworth's clever interpretation of the bottle's original creative brief to Paul Meates layered repurposing of vintage

Coca-Cola ads to Jovaney A. Hollingsworth's nod to modern Pop Art master Shepherd Fairey, we see that the contour bottle's form has transcended function. It remains by necessity a container, a vessel, and a dispensary, but one hundred years later it endures as a promise of quality and authenticity, as always, but also the first step—anticipating touch and sound and smell and, finally, taste—of the genuine Coca-Cola experience. It's a feeling as familiar as a memory, shared across the globe, unique and yet the same for everyone, everywhere.

With that, I invite you to enjoy this book's incredible collection of archival photographs, advertisements, and designs, plus the exciting new works of Icon + Mashup art. Better yet, grab some friends and family and some ice-cold bottles of Coke, and help us—to borrow a phrase we've been using around the office of late—Kiss the Past Hello.

Following pages: Pakpoom Silaphan, *Ali Punches on Coke,* 2012; mixed media on vintage metal sign, 18 x 35 1/2 in. (46 x 90 cm).

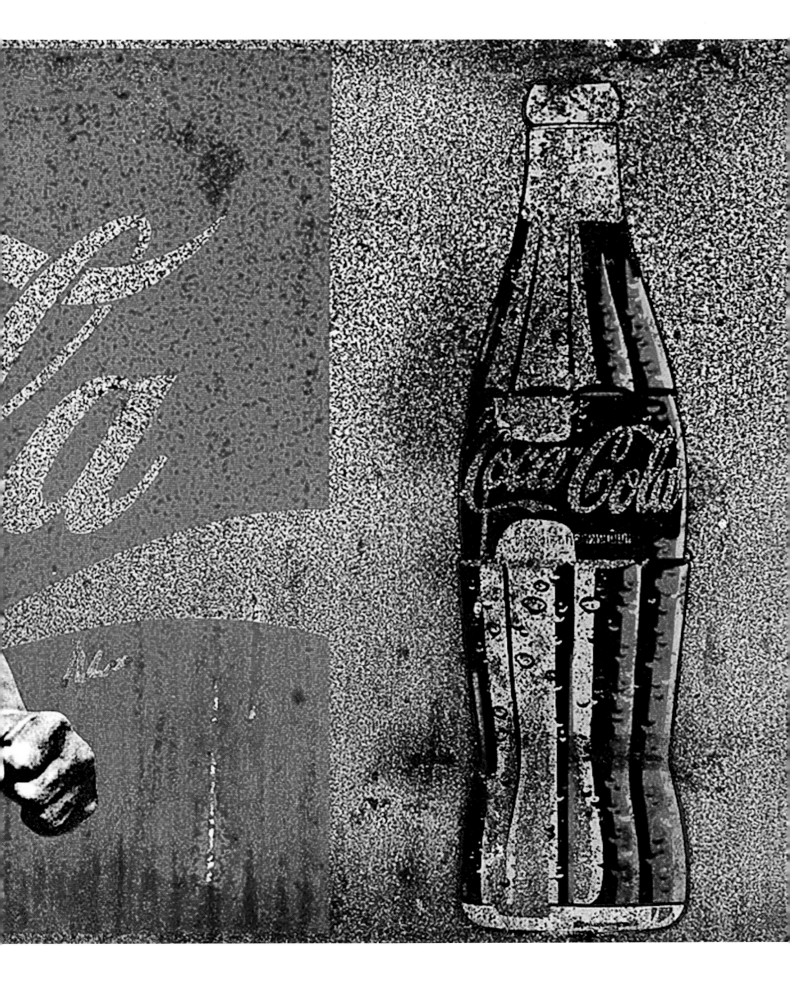

Lady in Red, Brazilian advertisment, 1950.
Previous pages, from left: Sally Tharp, *Two You,* 2011; oil on canvas, 48 x 36 in. (121.9 x 91.4 cm).
Stockholm Design Lab, *Imperfect Perfection,* 2014.

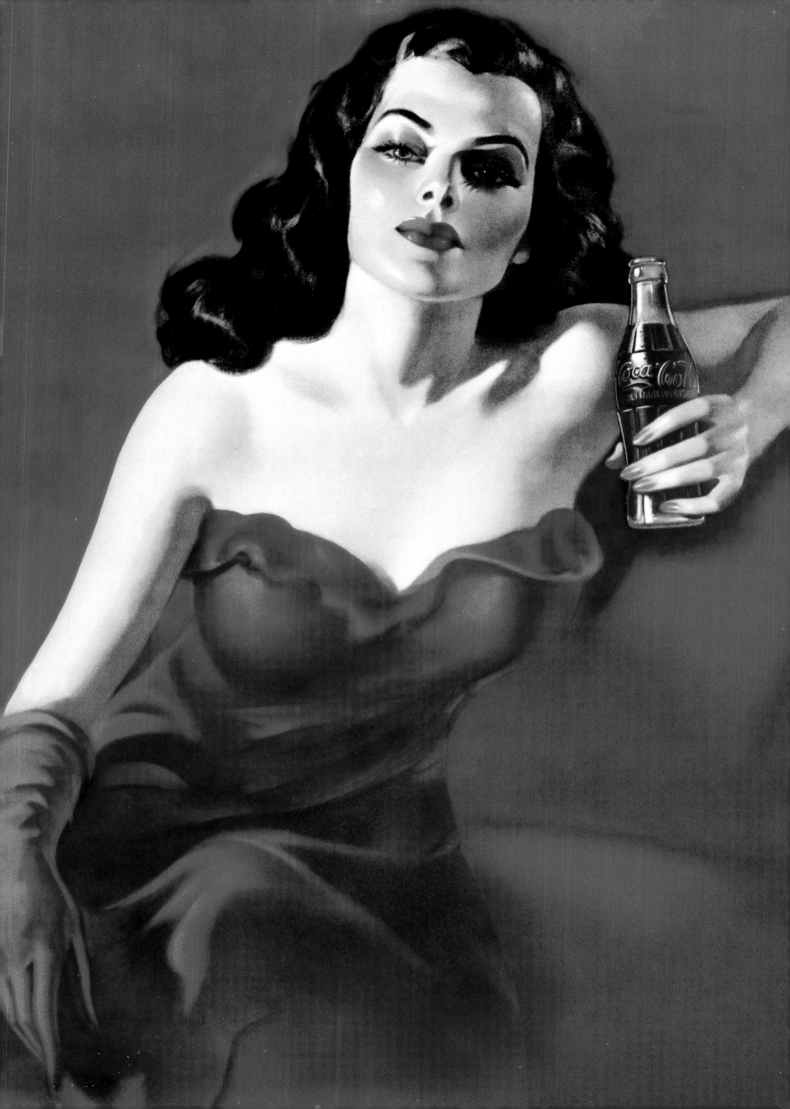

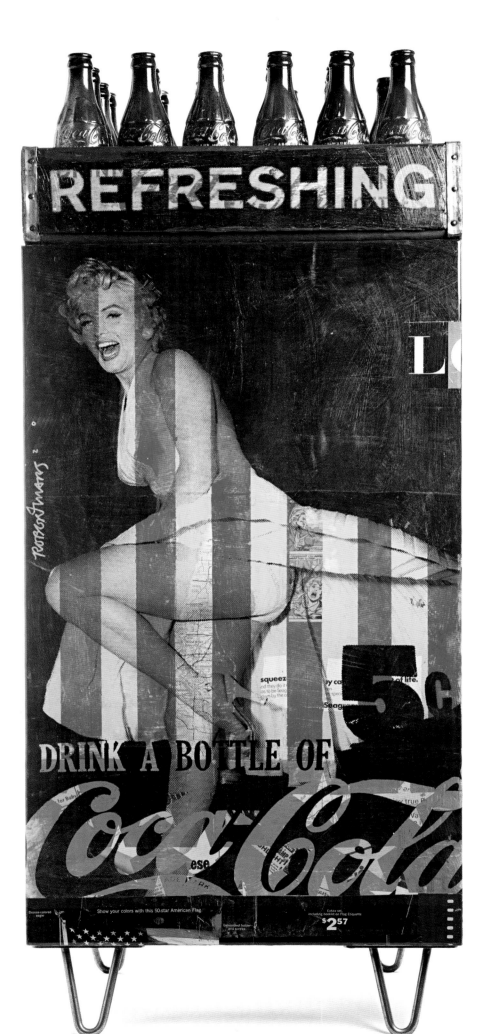

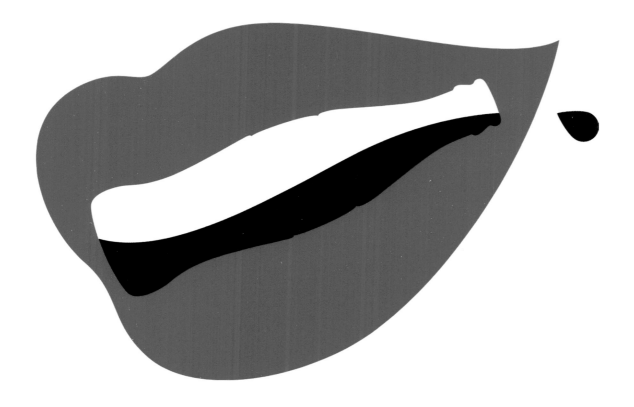

Rapha Abreu, Coca-Cola Design, *Lips*, 2014.
Opposite: Robert Mars, *Marilyn on a Pedestal*, 2012; mixed media on wood base
with epoxy resin, found objects and hairpin legs, 43 x 18 x 12 in. (109.2 x 45.7 x 30.5 cm).

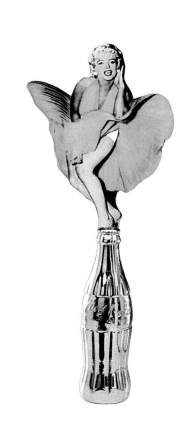

STUDY FOR SCULPTURE
1969 (COKE & MARILYN) 8/8 Clive Barker 1997

Clive Barker, *Study for Sculpture, 1969 (Coke & Marilyn)*, 1997; collage,
edition of 8, 30 3/4 x 20 1/2 in. (78 x 52 cm).
Opposite: Steve Kaufman, *Mona Lisa, A Coke and a Smile*, 2007;
hand painted oil on canvas silkscreen, 48 x 34 in. (121.9 x 86.4 cm).
Following pages: *Bottleware* by Nendo, produced by Ishizuko Glass, 2012.

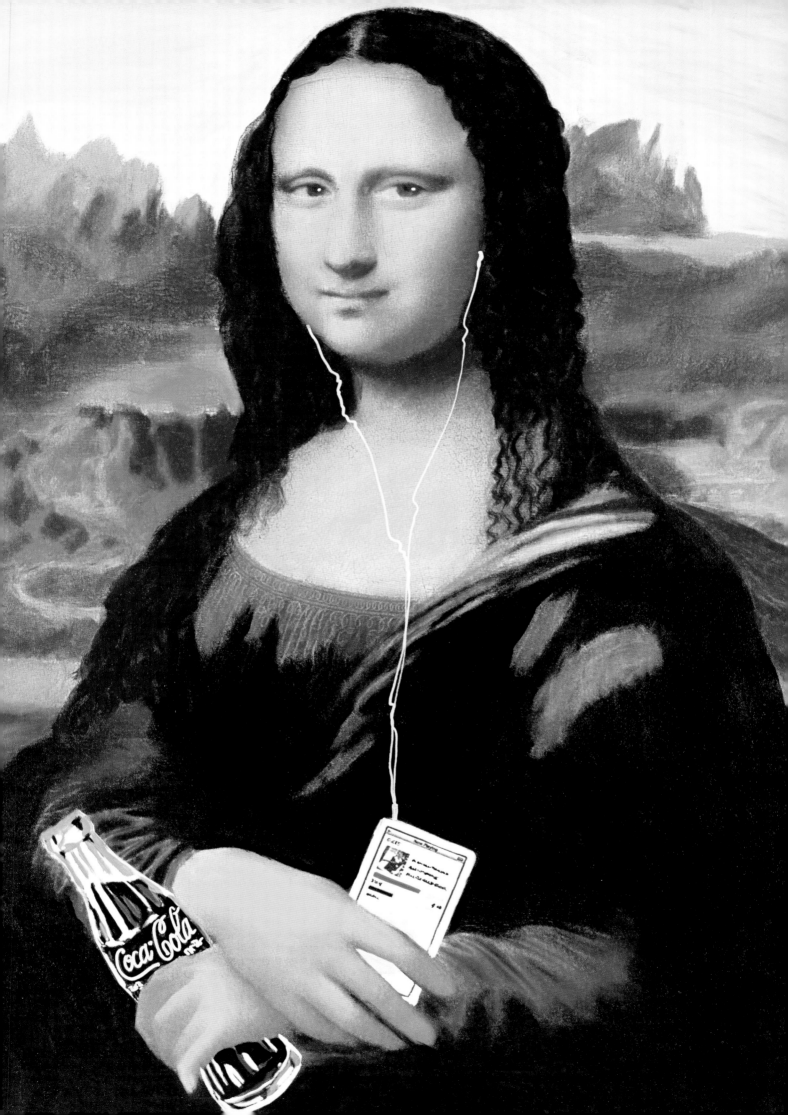

66 There are some designs that you know you can't beat. 99

Oki Sato
Industrial Designer

"We need a bottle which a person will recognize as a Coca-Cola bottle even when he feels it in the dark. The Coca-Cola bottle should be so shaped that, even if broken, a person could tell at a glance what it was."

Coca-Cola Bottle Brief

The Coca-Cola bottle.
Following pages: Four-part Coca-Cola bottle mold used to make the contour bottle, 1956.

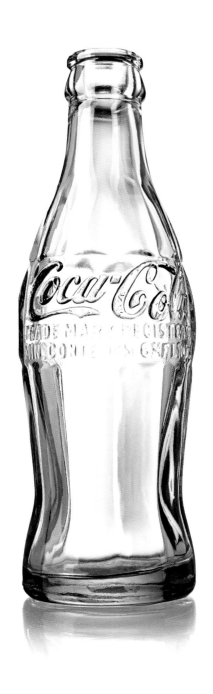

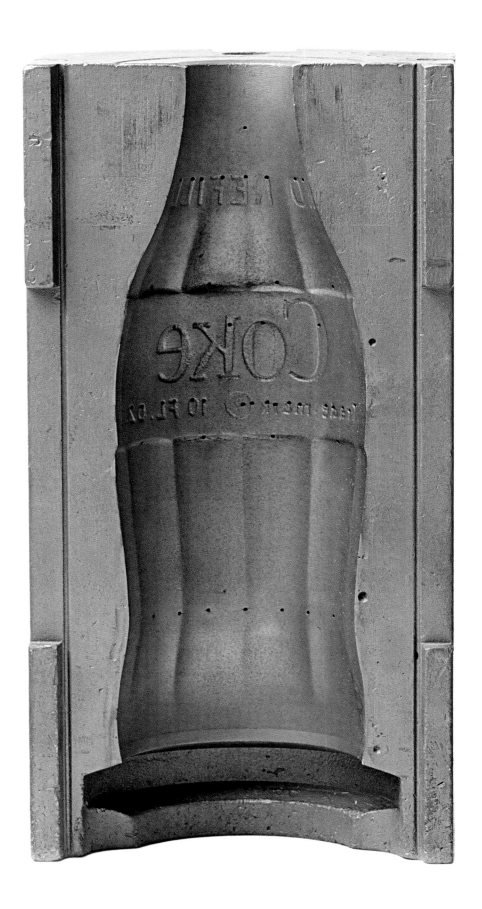

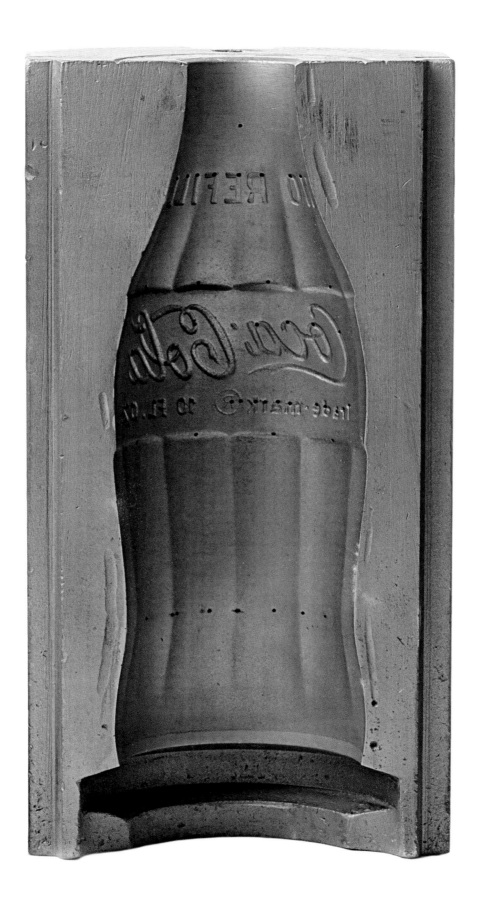

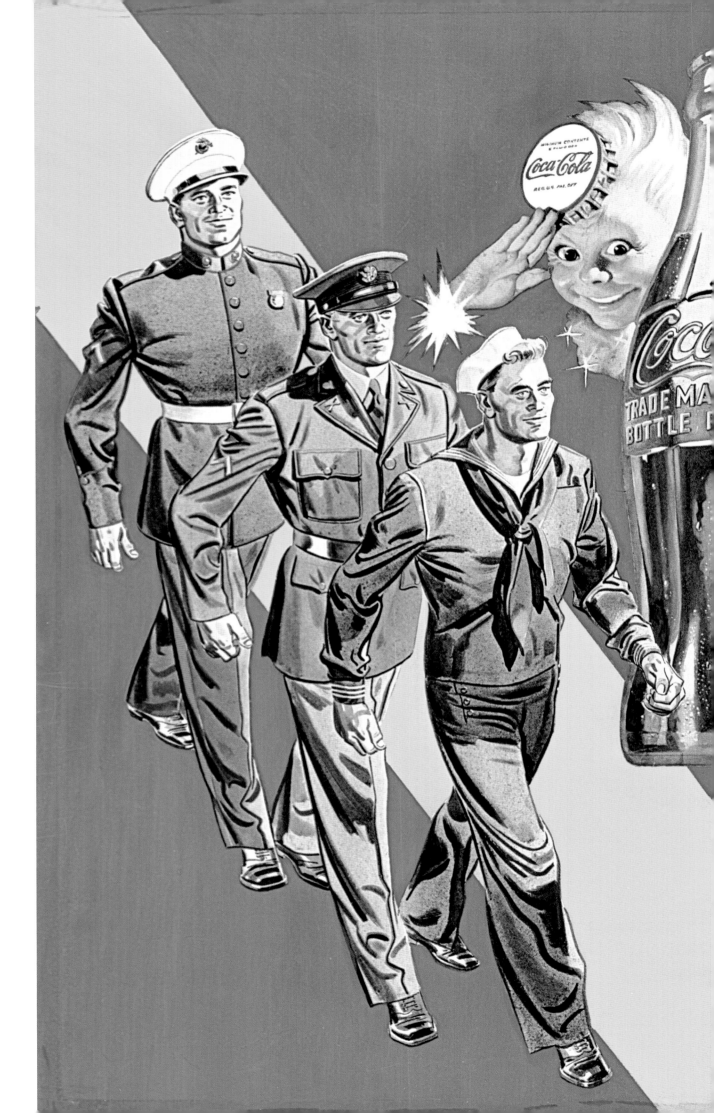

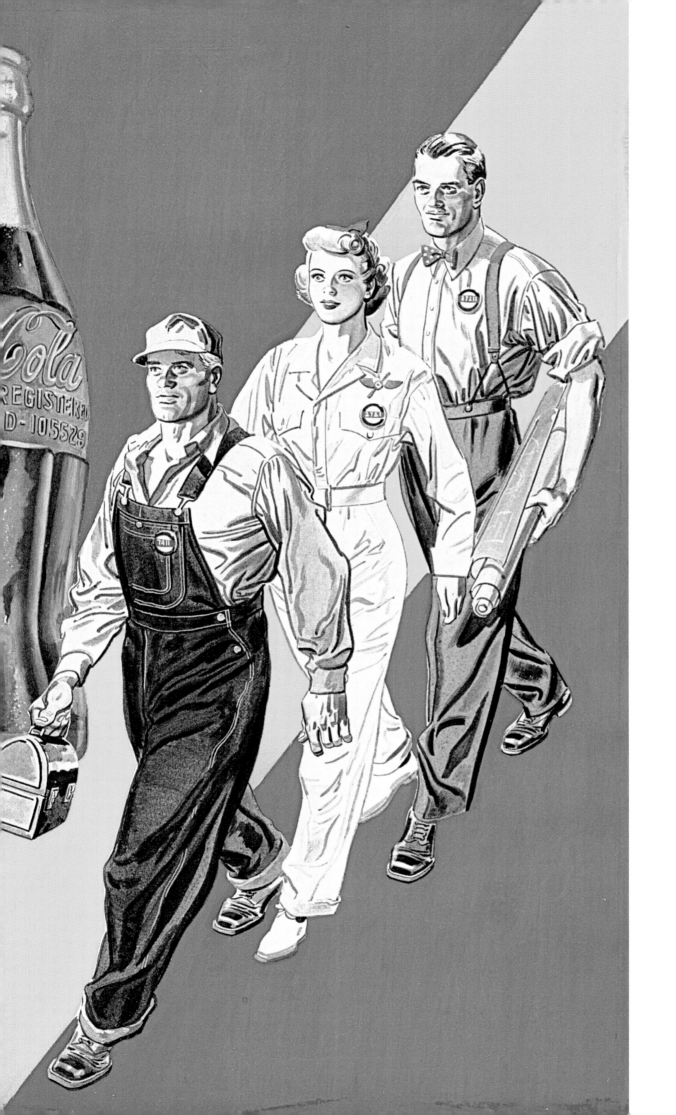

Robert Mars, *American Classic Neon*, 2014; mixed media
on panel with epoxy resin, 48 x 48 in. (121.9 x 121.9 cm).
Previous pages: Sprite Boy, Coca-Cola advertisment, 1943.

Andy Warhol, *Coca-Cola [4] [Large Coca-Cola],* 1962; acrylic,
pencil and Letraset on canvas, 81 3/4 x 56 3/4 in. (207.6 x 144.1 cm).
Following pages: Hidetaka Matsunaga, Coca-Cola Design, *Slice,* 2014.

REG. U.S. PAT. OFF.

"Chanel N°5, Wayfarers, Rolex Submariner, Levi's 501, and the Coca-Cola bottle. Dress them up, dress them down, they are pop culture icons, ubiquitous, timeless, and desirable."

Deklah Polansky
Graphic Designer

Pakpoom Silaphan, *Picasso draws on Coke button*, 2013;
mixed media on vintage metal sign, 35 1/2 in. (90 cm) in diameter.

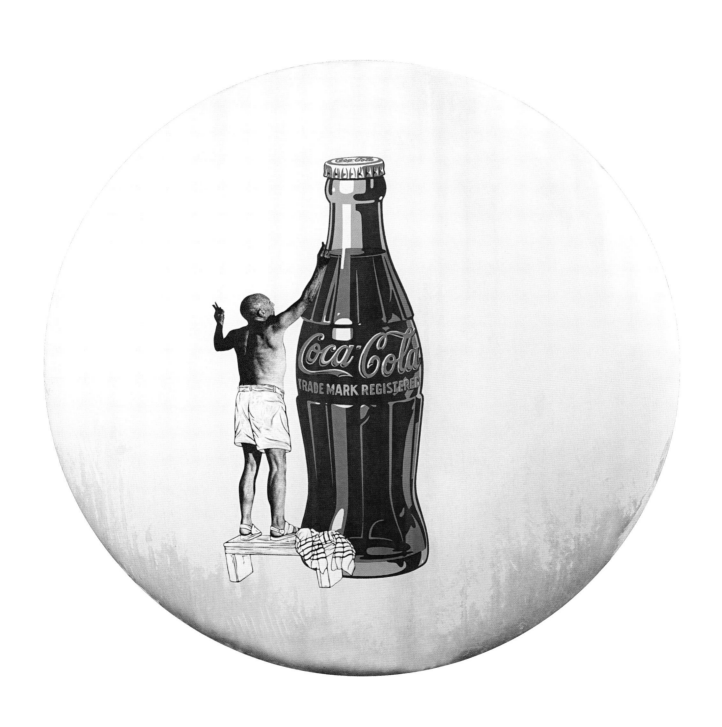

James Rosenquist, *Hey! Let's go for a Ride,* 1961;
oil on canvas, 34 x 36 in. (86.5 x 91.2 cm).
Following pages, from left: Print advertisement, 1942.
Matthew Kenyon, *Upside,* 2014.

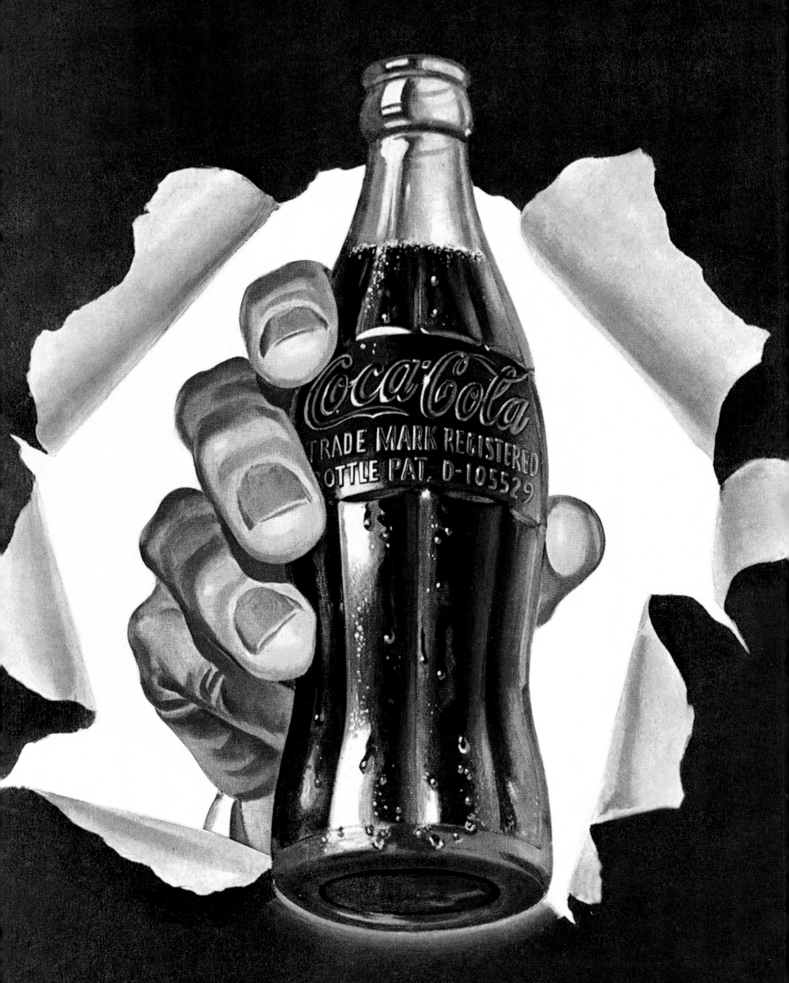

Paper coaster design, 1983.
Opposite: David Schwen, Dschwen LLC, *Happy,* 2014.

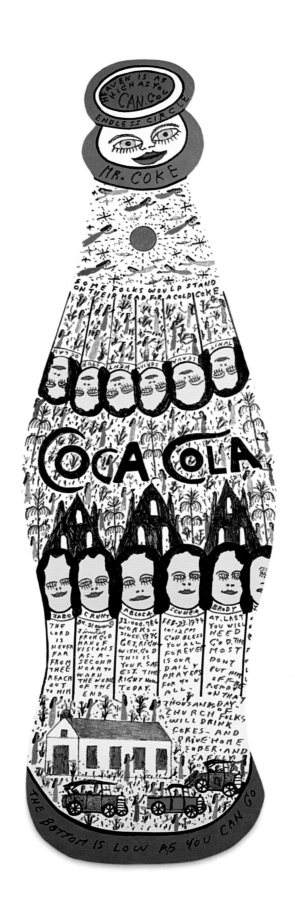

Howard Finster, *Endless Circle (#32,786 Coca-Cola Bottle)*,
February 23, 1994; enamel on wood, 34 1/2 x 10 1/2 in. (87.6 x 26.7 cm).
Opposite: HI(NY), *La la la Coca-Cola*, 2014.

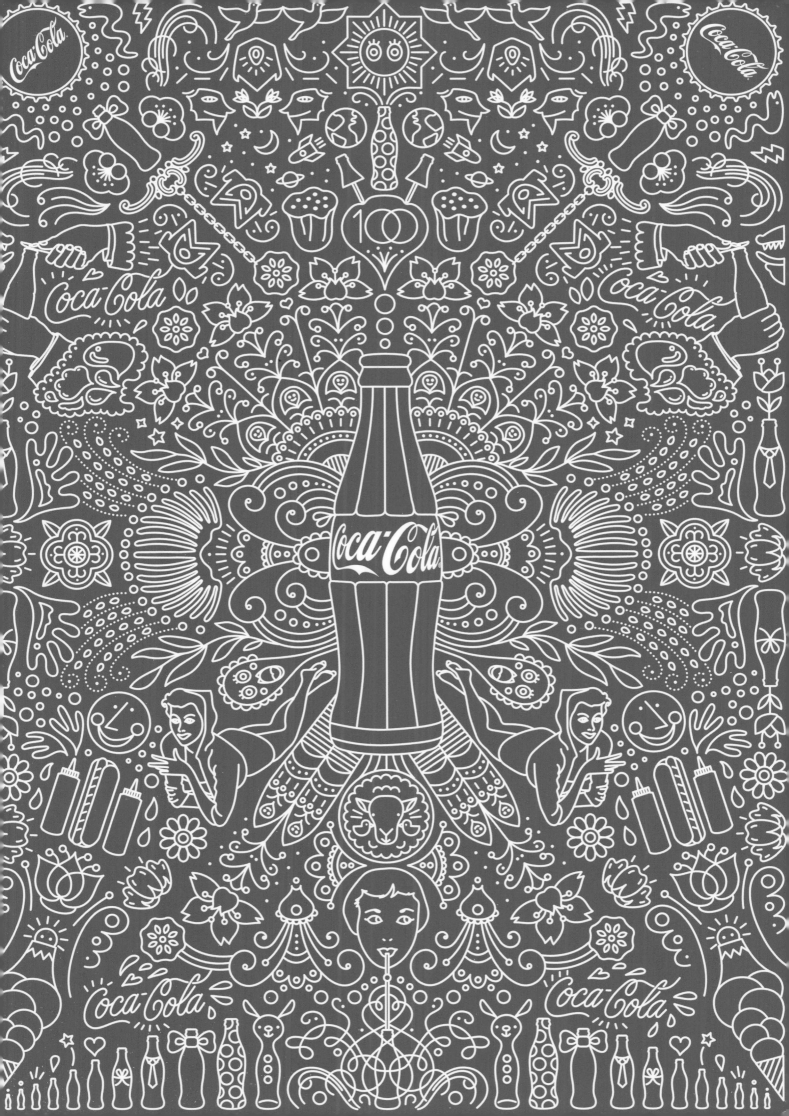

"When you pop a bottle of Coke, you pop a smile because from your very first sip you know that you get to be a part of something timeless."

Mr. Brainwash
Artist

Upendo Taylor, *That Real*, 2014.
Following pages, from left: Matt Allen, Coca-Cola Design, *Adds Life to Everything Nice*, 2014.
Stefan Kjartansson, Armchair Media, *Love at first sip!*, 2014.

Tom Wesselmann, *Still Life #12*, 1962; acrylic
and collage of fabric, photogravure, metal, etc.
on fiberboard, 48 x 48 in. (122 x 122 cm).

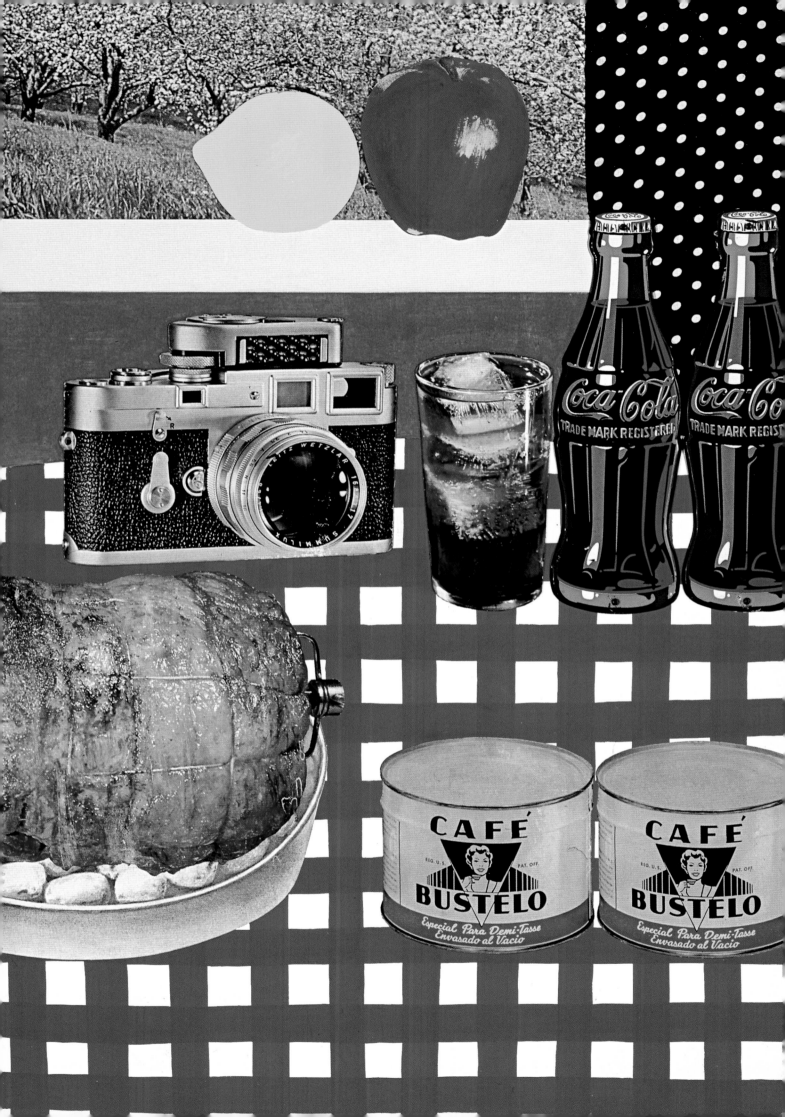

"Since it was first introduced 100 years ago, the unmistakable design of the Coke bottle has helped make it an icon of popular culture."

David Turner
Graphic Designer

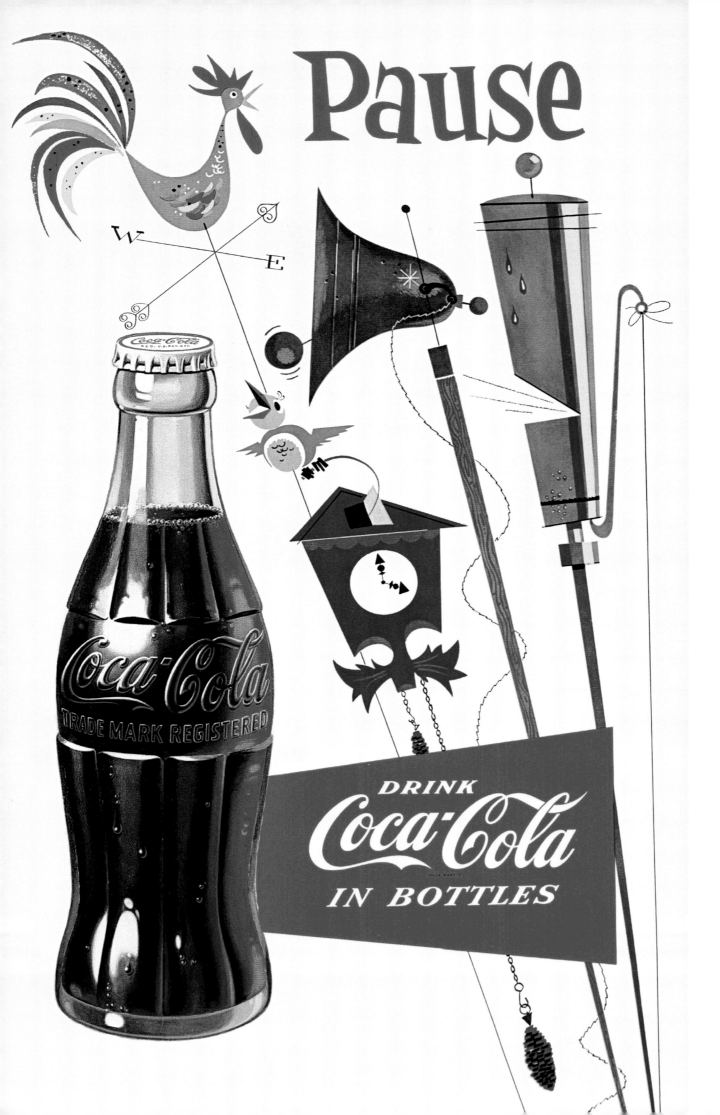

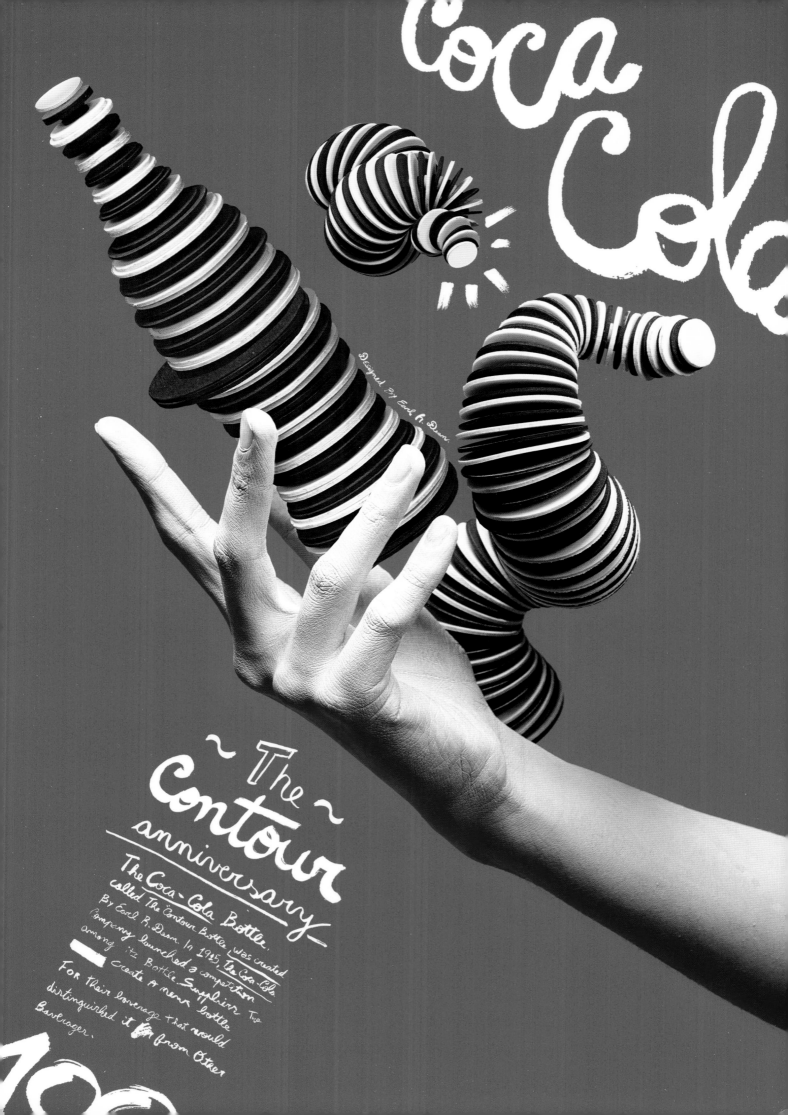

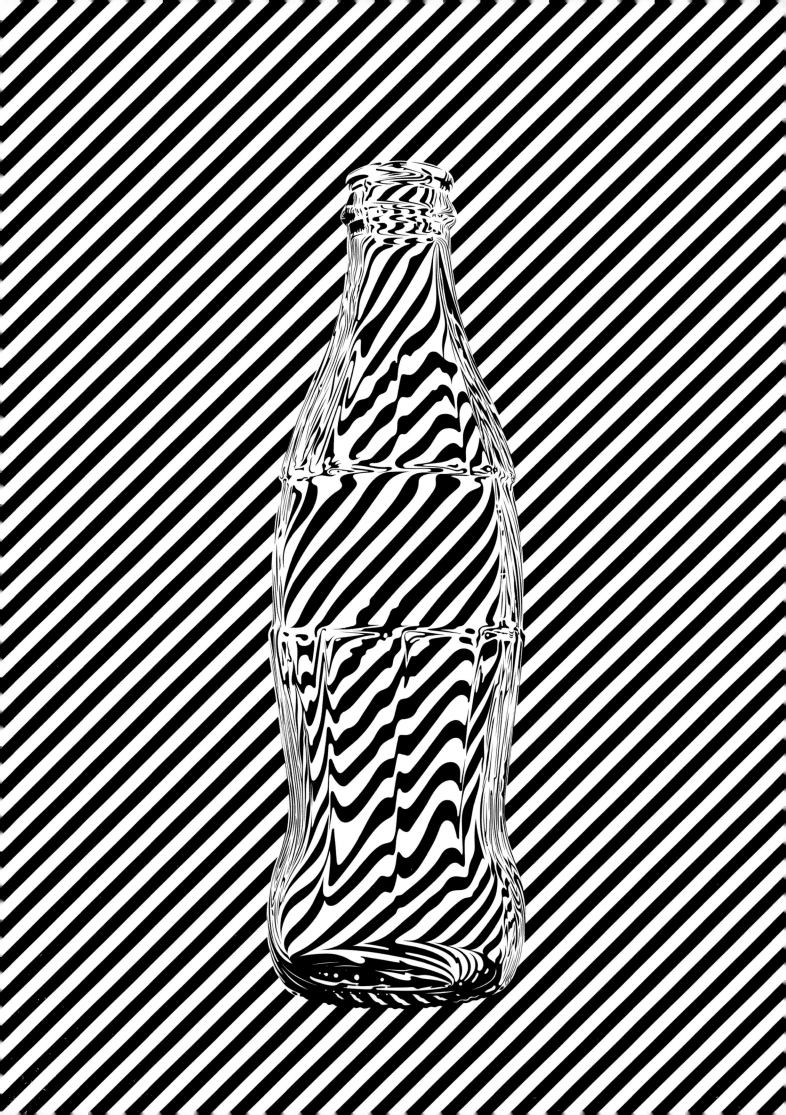

"A billion hours ago... human life appeared on earth. A billion seconds ago... The Beatles changed music forever. A billion Coca-Colas ago... was yesterday morning. "

Roberto Goizueta
Former CEO, The Coca-Cola Company, 1996

Christian Montenegro, *Verano*, 2014.
Previous pages, from left: Sir Peter Blake, *Summer Days (Coke side of life),* 2007;
silkscreen print commemorating installation commissioned by Coca-Cola
in August 2007; edition of 175, 43 1/2 x 25 1/4 in. (110.6 x 64 cm).
Sawdust, *1915,* 2014.

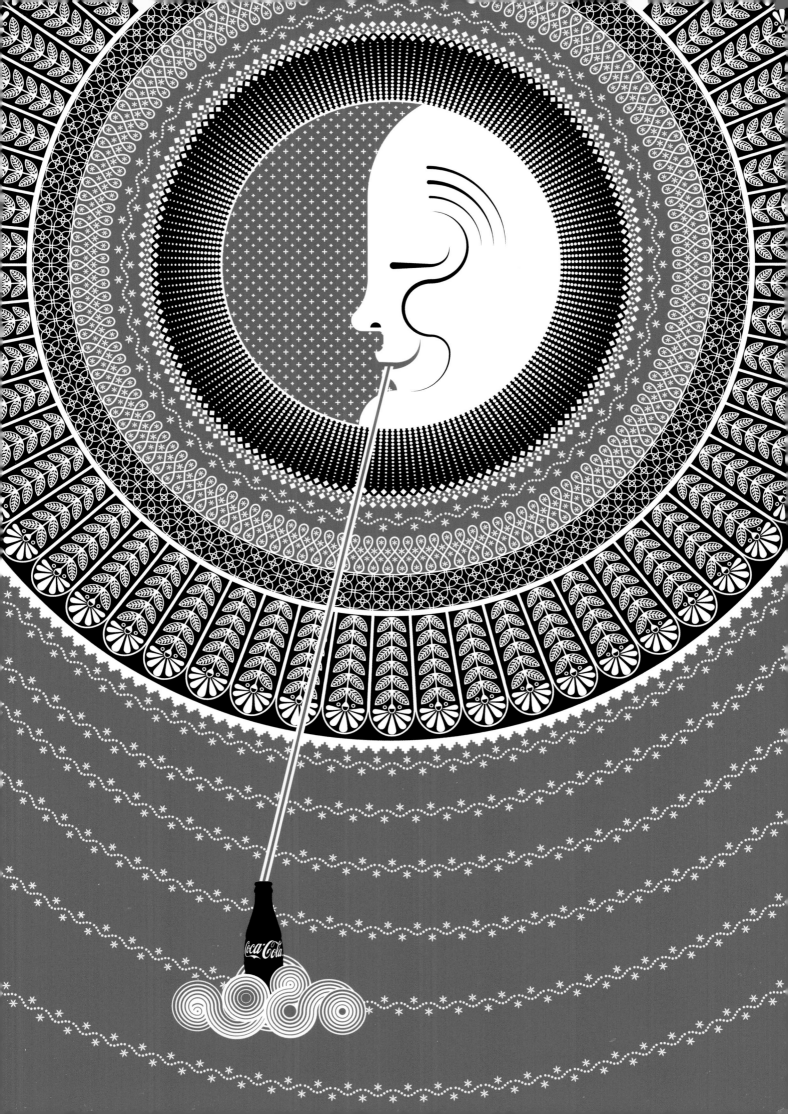

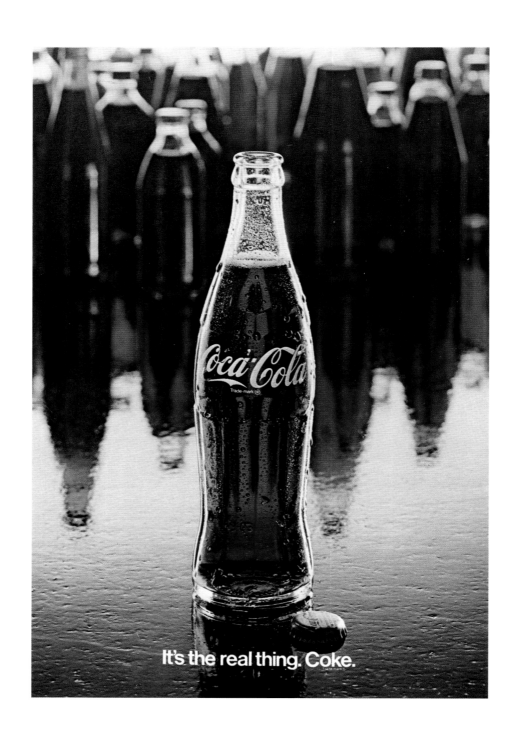

It's the real thing. Coke.

American print advertisement, 1975.
Opposite: Todd Ford, *Coke Bottle,* 2011; oil on canvas, 36 x 24 in. (91.4 x 61 cm).

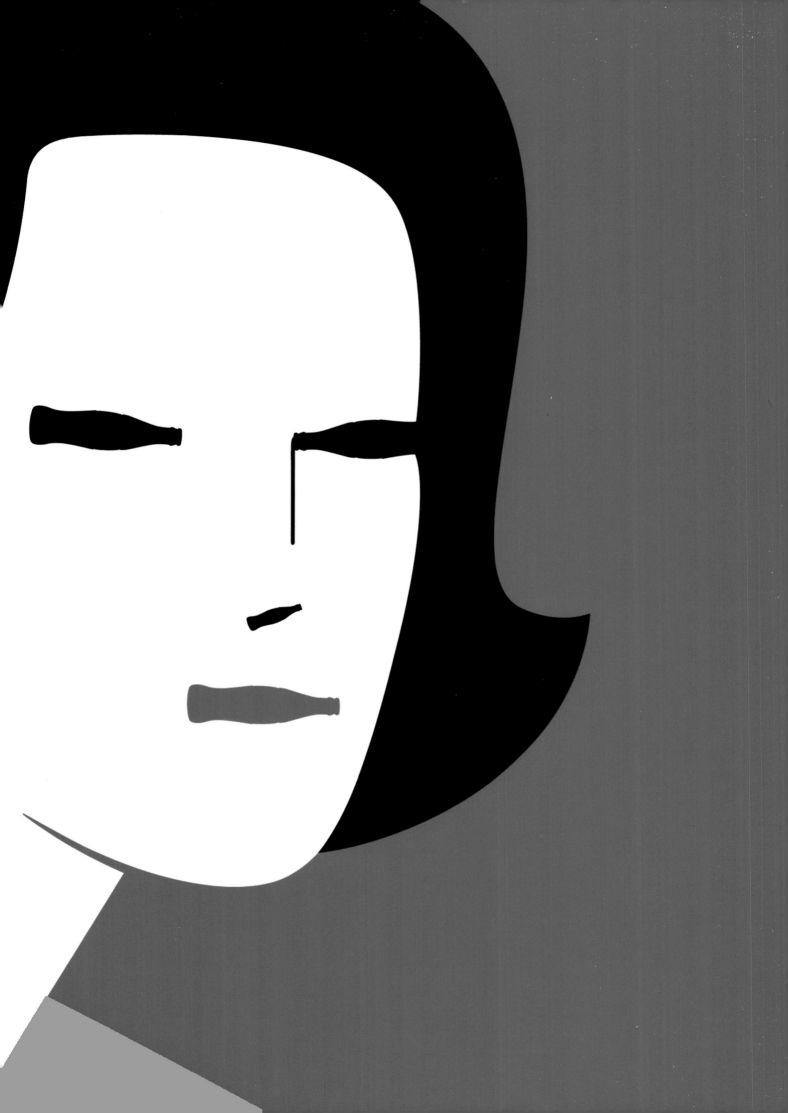

Kim Frohsin, *Coke Portrait: Neon,* 2010; collage, acrylic
and ink on archival board, 10 x 10 in. (25.4 x 25.4 cm).
Previous pages, from left: Noma Bar, *Lady Pemberton,* 2014.
Ashley Tipton, Coca-Cola Design, *Kaleidoscope,* 2014.

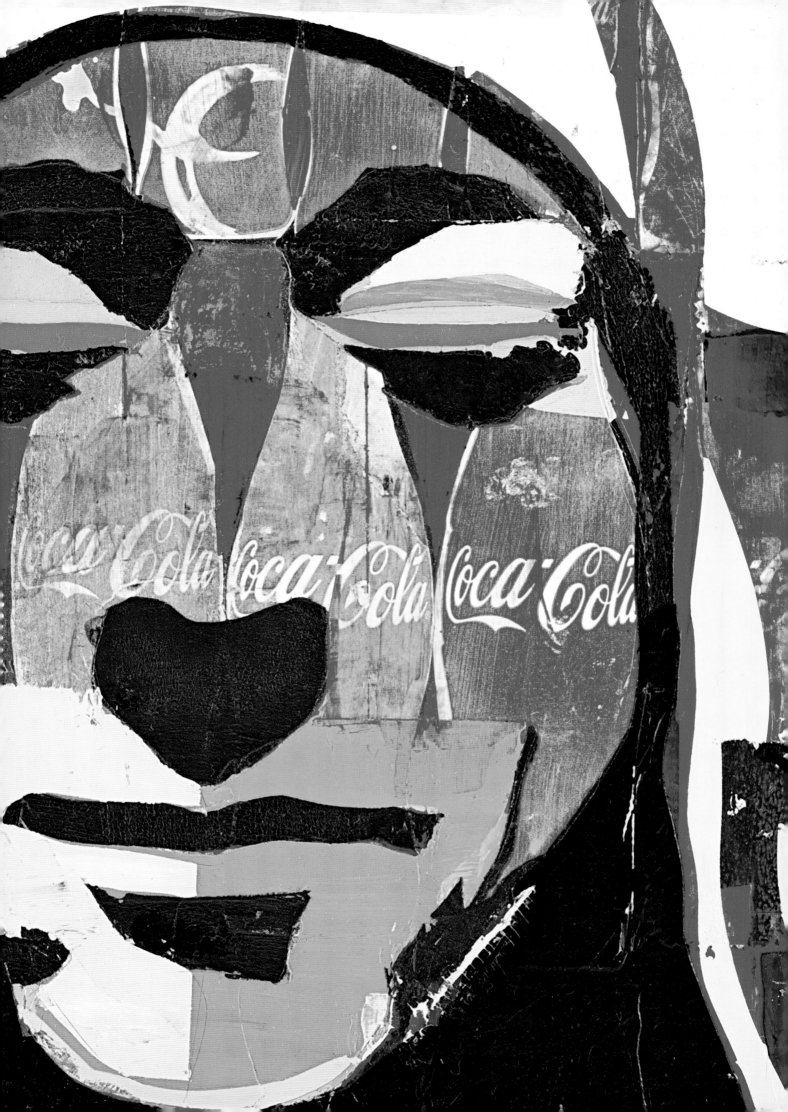

Kim Frohsin, *Big Layer: Three Coke,* 2011; collage, acrylic,
dry pigment and ink on panel, 8 x 8 1/4 in. (20.3 x 21 cm).

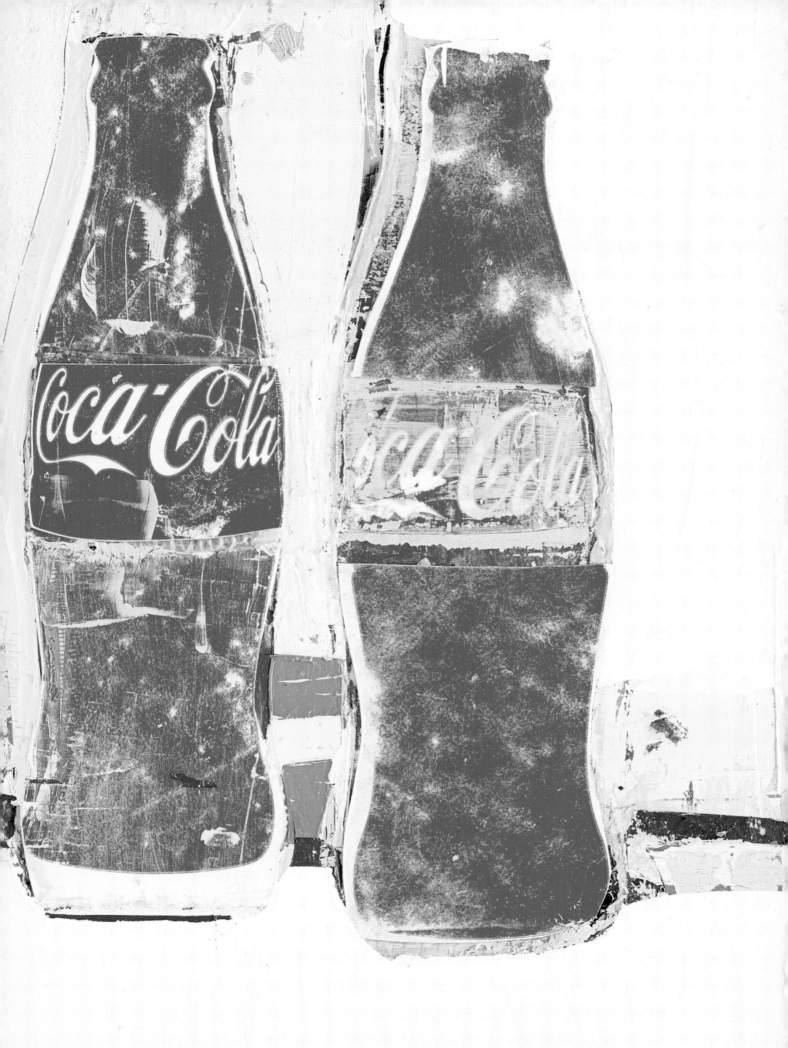

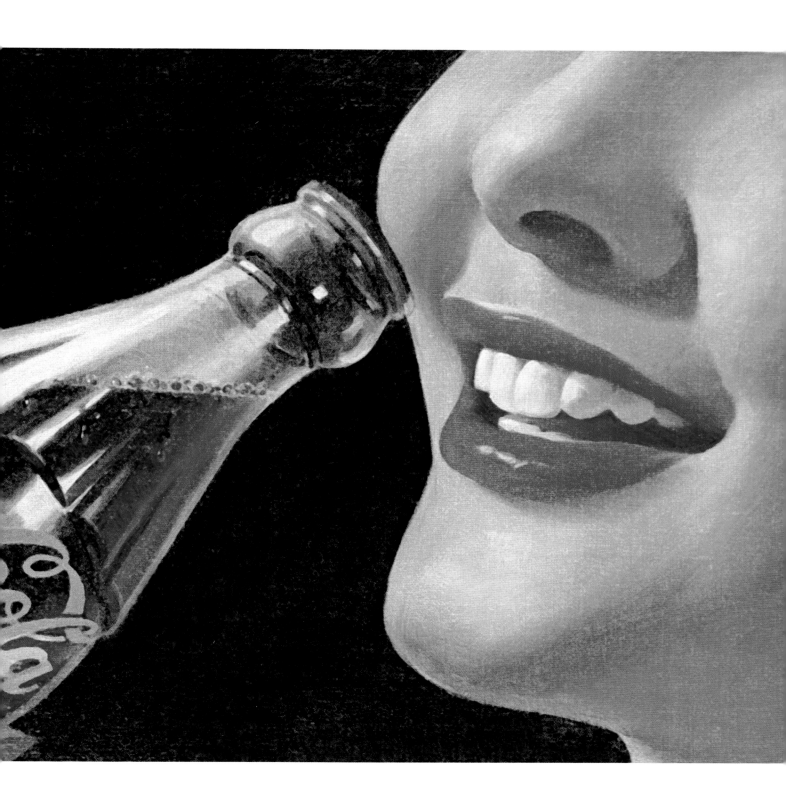

Original painting used for posters and calendars in the United States, 1951.
Following pages, from left: Ivan Khmelevsky, The Bakery, *Hundredfold,* 2014.
Tom Farrell, Coca-Cola Design, *Perpetual Bottles,* 2014.

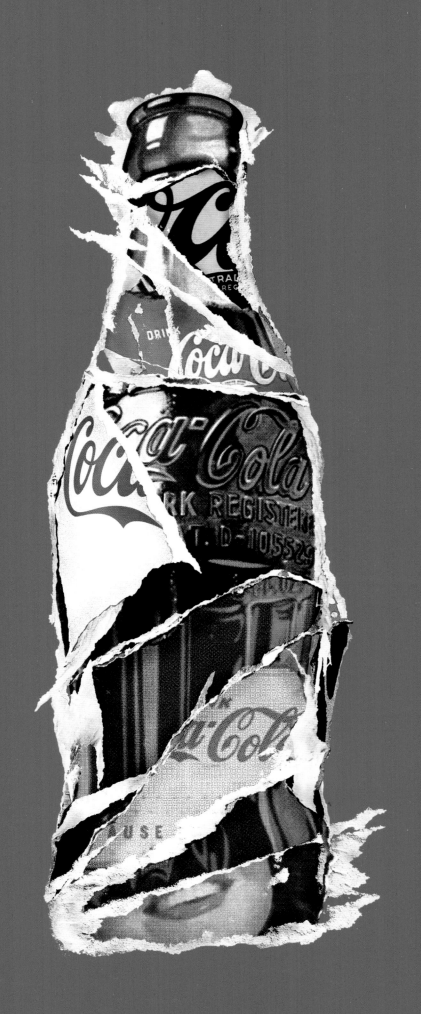

66 The Coca-Cola bottle recalls dreamy images of my childhood and reminds me of the possibility of continuity and the power of tradition. The sensuality and energy of its curves inspire a kind of endless resonance, as if landing in water. The bottle proves that good design works, that iconic designs are firmly fixed in our modern social and cultural lexicon. 99

Neville Brody
Graphic Designer

Metal advertising sign introducing the 16-ounce Coca-Cola bottle for home consumption, 1950.

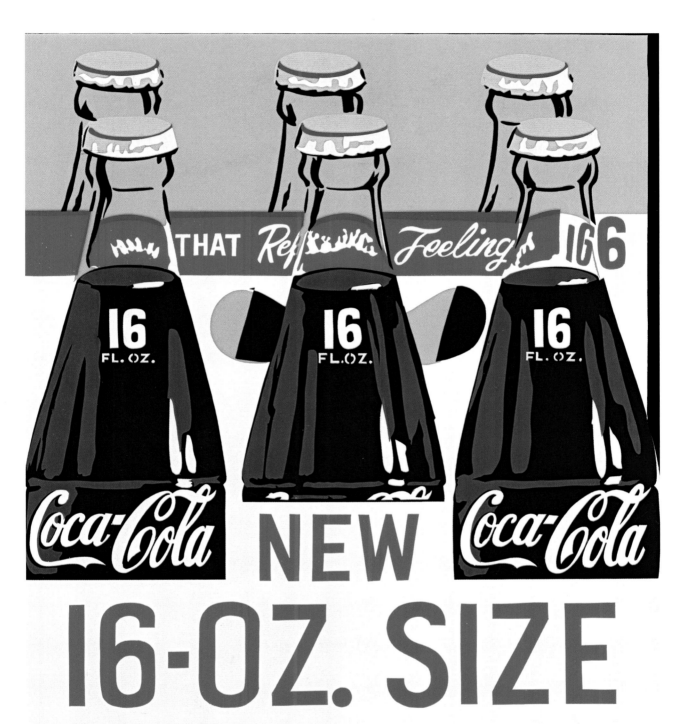

Klaus Staeck, *Coca-Cola II,* 1970; silkscreen on cardboard, edition of 25, 29 1/8 x 23 5/8 in. (74 x 60 cm).

"White T-shirt, blue jeans, and the Coke bottle are my timeless standard."

Nigo
Designer

Forpeople, *30°*, 2014.
Following pages: Blueprint for the Coca-Cola bottle, 1960.

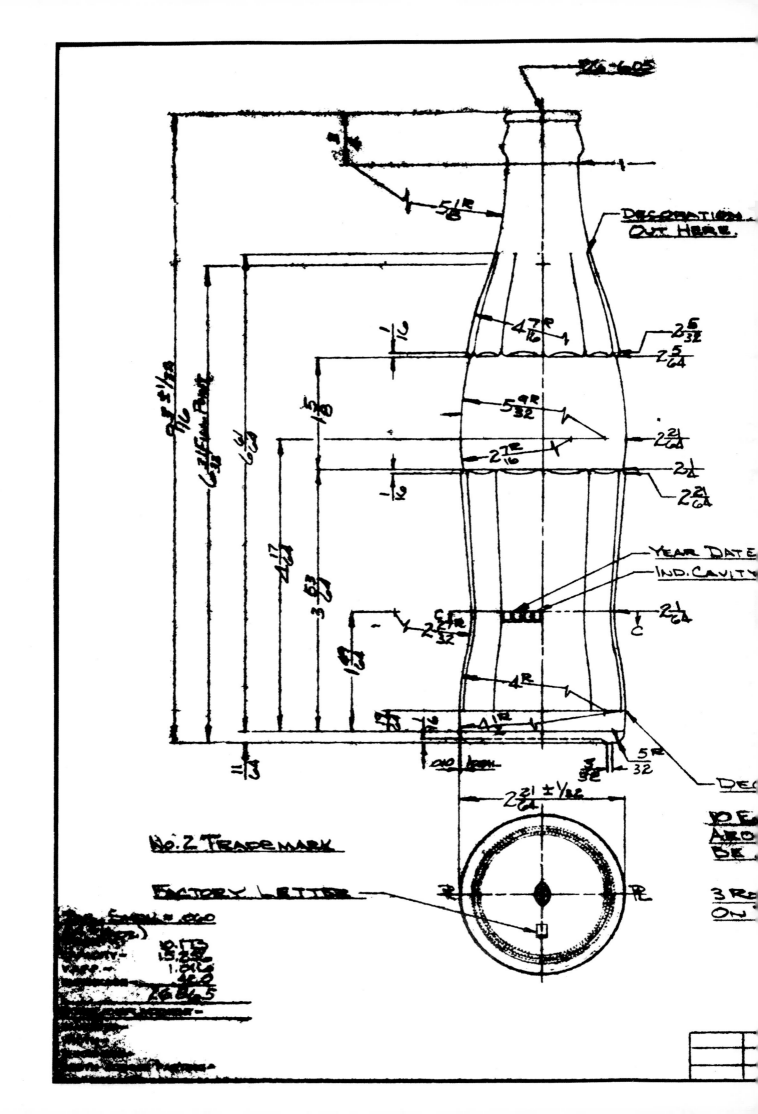

DECORATION
CUT HERE.

YEAR DATE

IND. CAVITY

No. 2 TRADEMARK

FACTORY LETTER

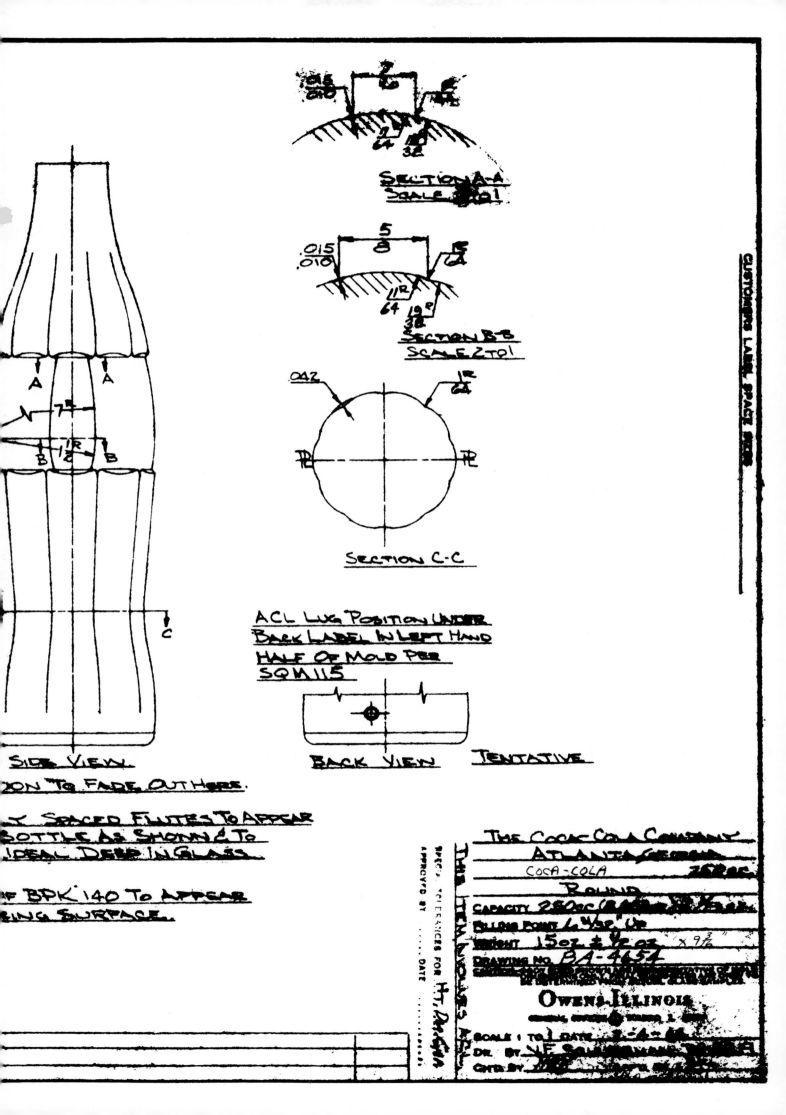

SECTION A-A
SCALE __ TO 1

.015
.010

SECTION B-B
SCALE 2 TO 1

SECTION C-C

A A

7⅛

1½" R

B B

C

SIDE VIEW

ACL LUG POSITION UNDER
BACK LABEL IN LEFT HAND
HALF OF MOLD PER
SQM 115

BACK VIEW TENTATIVE

___ ON TO FADE OUT HERE.

___ SPACED FLUTES TO APPEAR
___ BOTTLE AS SHOWN & TO
___ IDEAL DEEP IN GLASS.

___ BPK 140 TO APPEAR
___ ING SURFACE.

THE COCA-COLA COMPANY
ATLANTA GEORGIA
COCA-COLA
ROUND
CAPACITY 250 cc
FILLING POINT 6 4/32 Up
WEIGHT 15 oz ± ½ oz x 9¾"
DRAWING NO. BA-4654

OWENS-ILLINOIS

SCALE 1 TO 1 DATE
DR. BY
CHD. BY

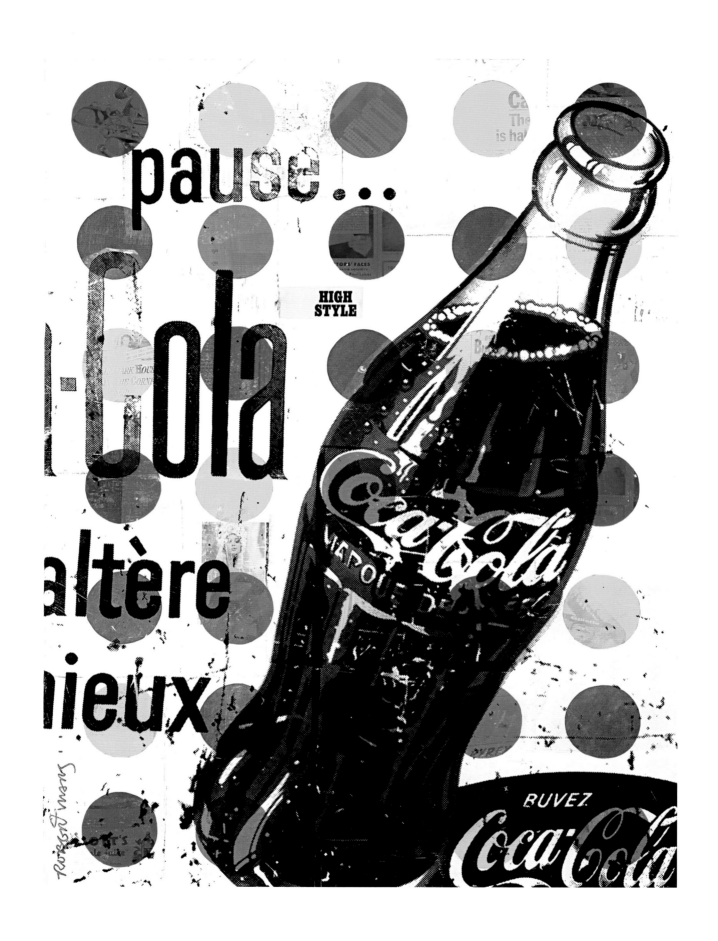

Robert Mars, *High Style,* 2011; mixed media on panel with epoxy resin,
40 x 30 in. (101.6 x 76.2 cm).
Opposite: La Boca, *Forward Going Backward,* 2014.

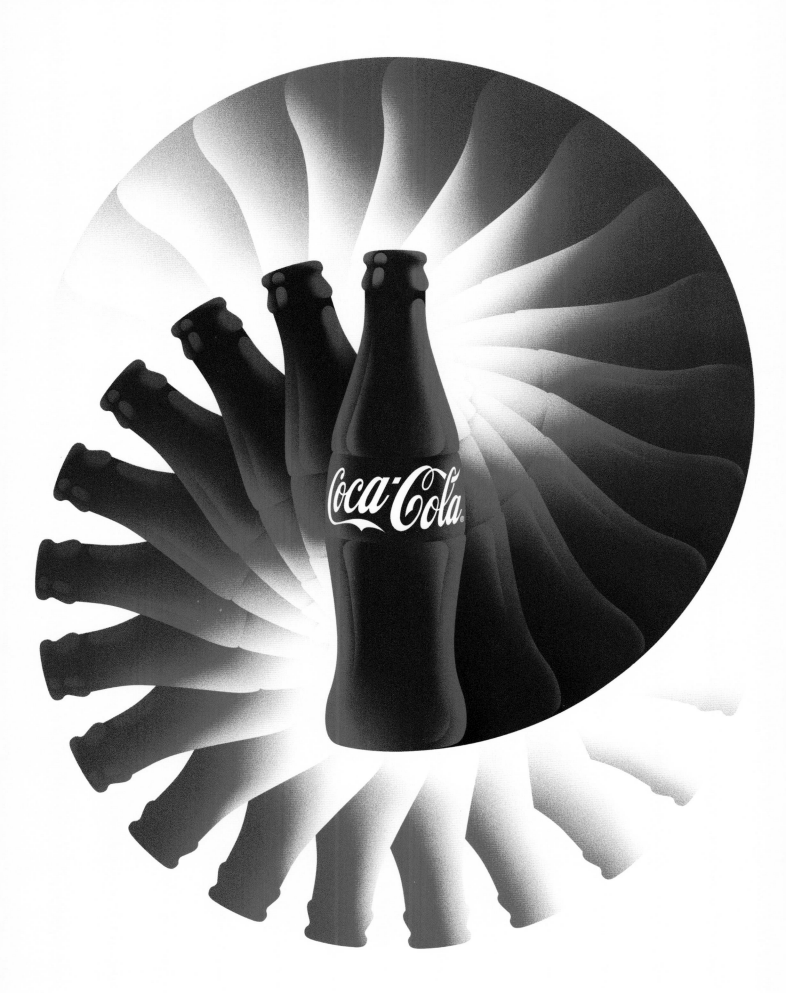

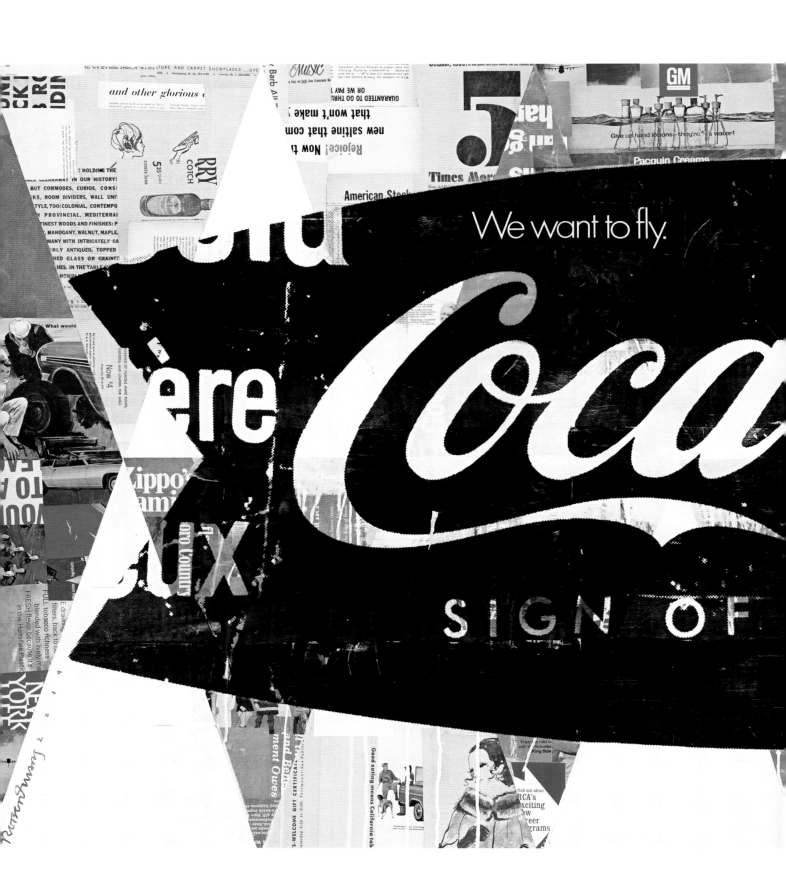

Robert Mars, *We Want to Fly*, 2014;
mixed media on panel with epoxy resin, 40 x 80 in. (101.6 x 203.2 cm).

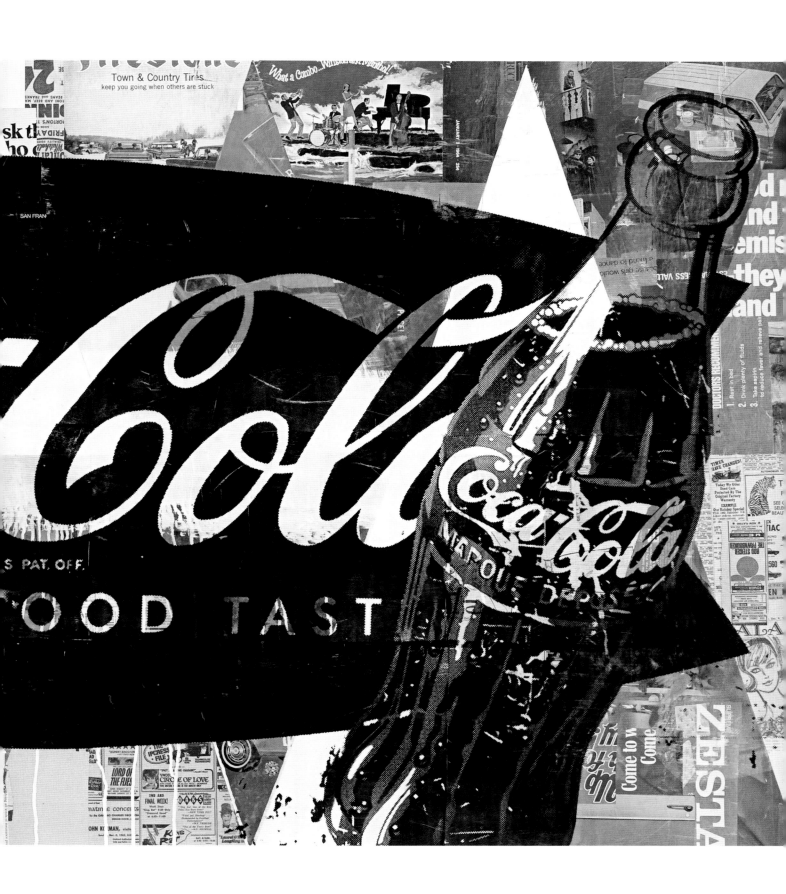

Following pages, from left: Jess Wilson, Agency Rush, *Have a Coke,* 2014.
Deklah Polansky, Coca-Cola Design, *Lovers,* 2014.

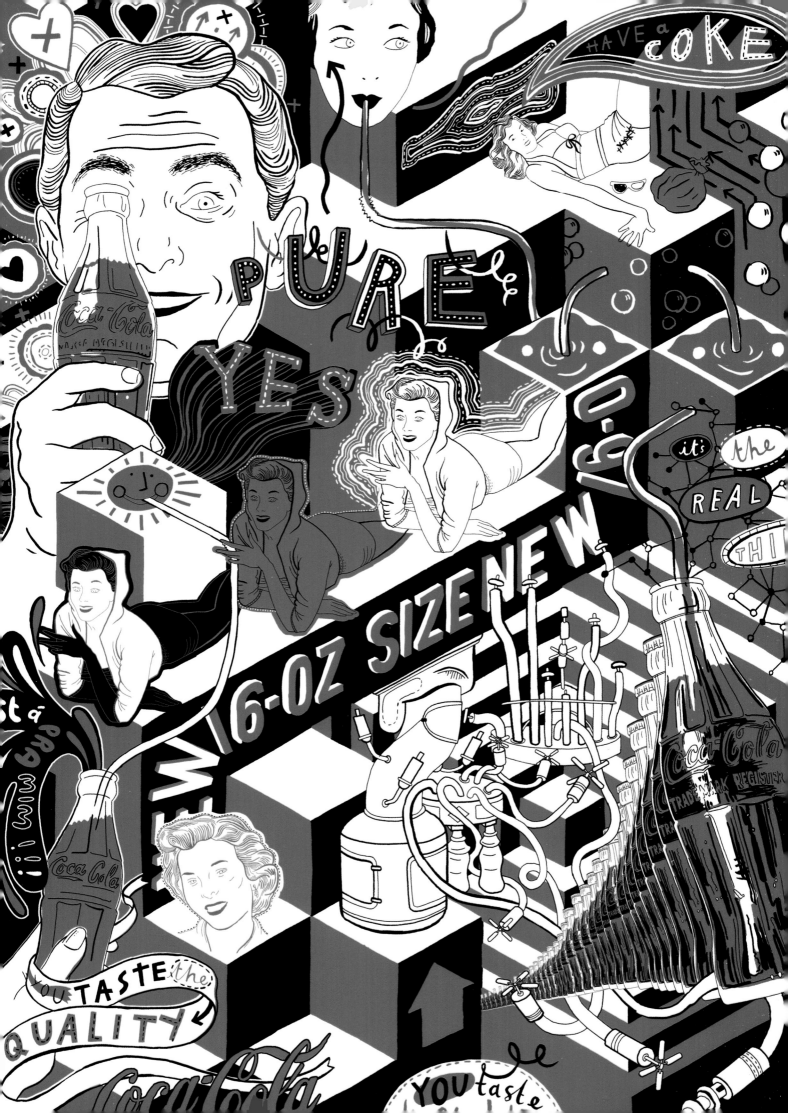

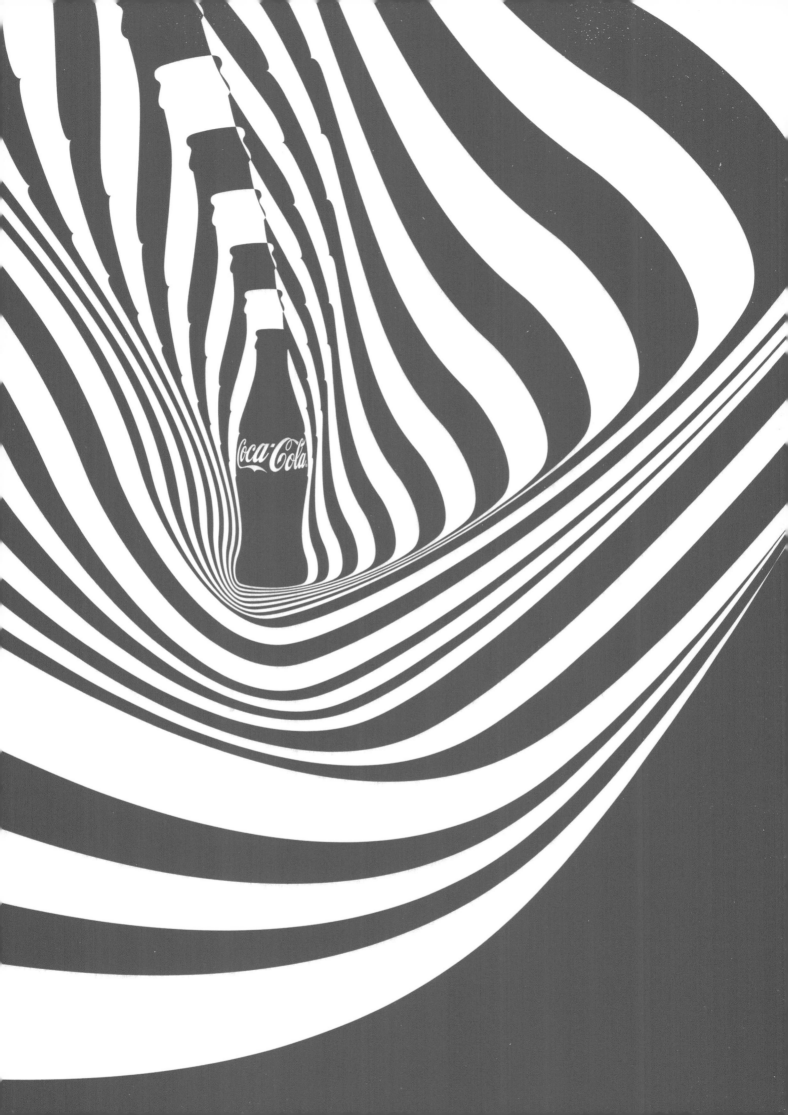

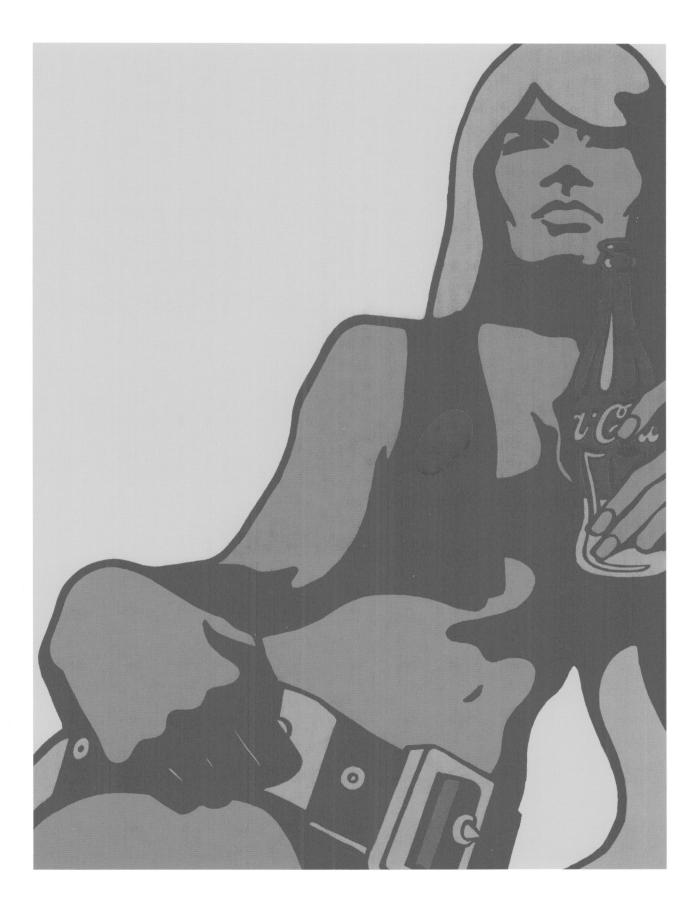

Guy Peellaert, *Pravda & Coca Cola,* 1967; silkscreen print, printed 2004, 45 1/4 x 30 3/4 in. (115 x 78 cm).
Opposite: Neville Brody, *Resonance,* 2014.

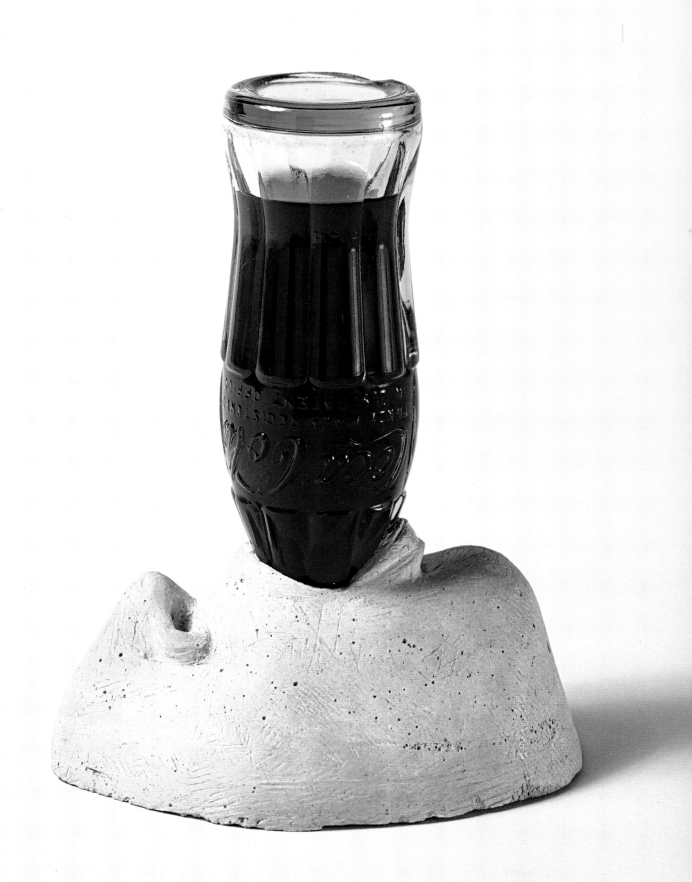

here's nothing like a 'Coke'

Bottled under authority of The Coca-Cola Company by

COCA-COLA SOUTHERN BOTTLERS LTD., SOUTHFIELD ROAD, LONDON. W4

'Coca-Cola' and 'Coke' are the registered trade marks of The Coca-Cola Company

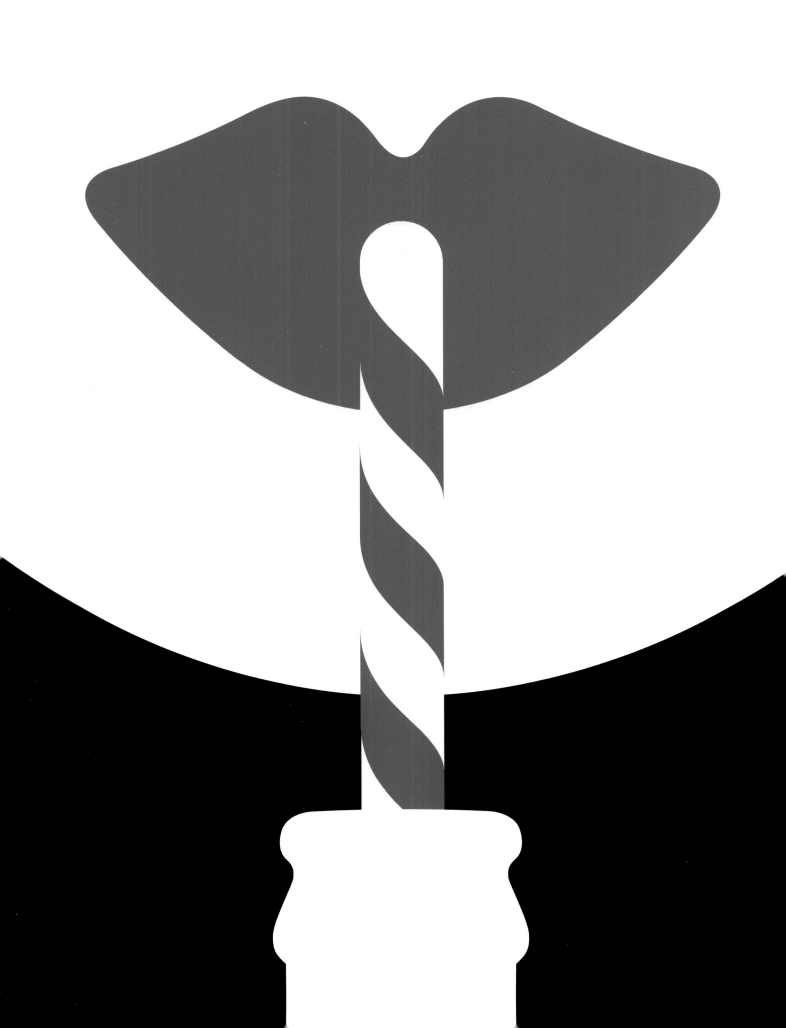

South African print advertisement, 1955.
Previous pages, from left: British advertisement,
1956. CMA Design, *Smile*, 2014.
Page 94: Marisol Escobar, *Love,* 1962;
plaster and glass (Coca-Cola bottle),
8 1/8 x 6 1/4 x 4 1/8 in. (20.6 x 15.8 x 10.5 cm).
Page 95: Mr. Brainwash, *I Will Always Love You,* 2014.

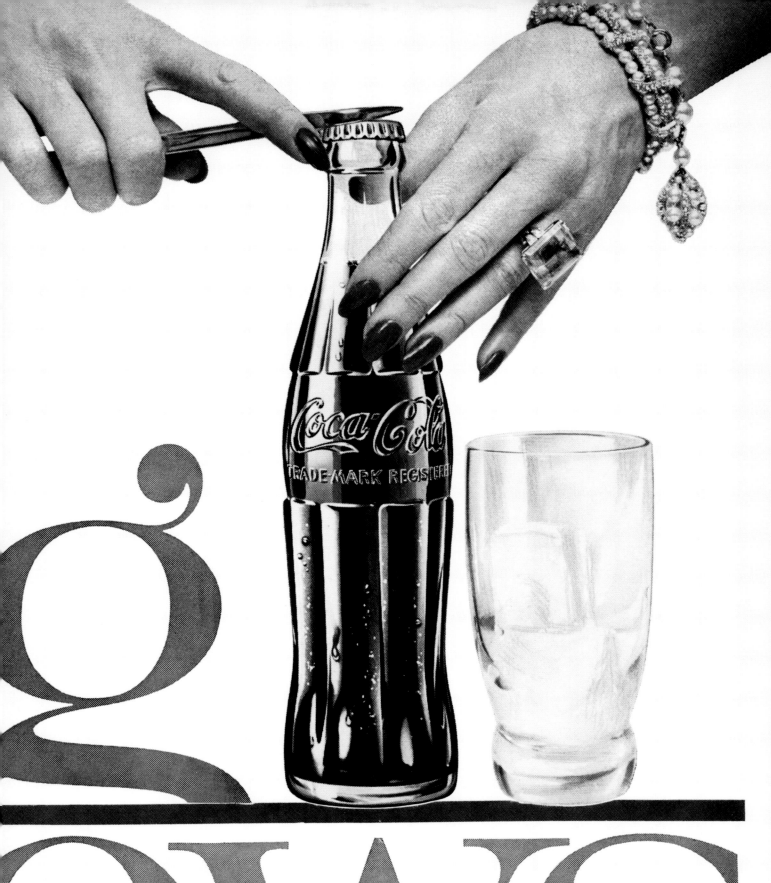

"The Coca-Cola bottle has been in my life since WWII. I remember it in the uplifting ads during and after the war. As a grade school student I remember the magic of going to the corner store after a hot dusty ball game and having a Coke in that crispy cold bottle. Now, as a designer, I see it as distinctive, practical, memorable, and sensual. It's a design legend that has just turned 100 and is still going."

Lance Wyman
Graphic Designer

Advertising poster, 1947.

CONTINUOUS QUALITY
IS QUALITY YOU TRUST

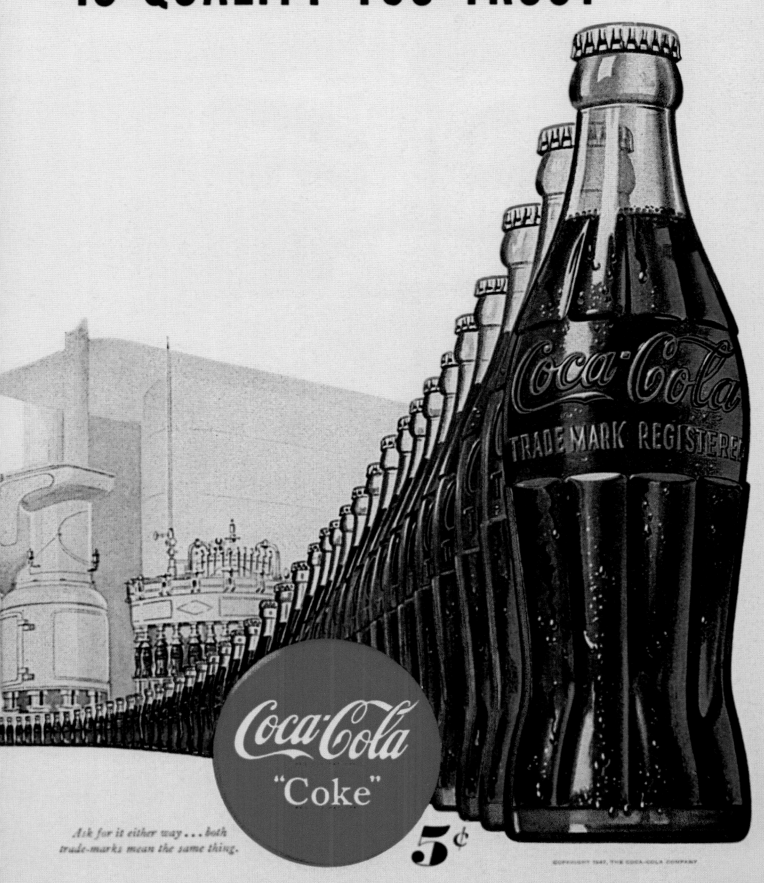

Coca-Cola

"Coke"

Ask for it either way...both trade-marks mean the same thing.

5¢

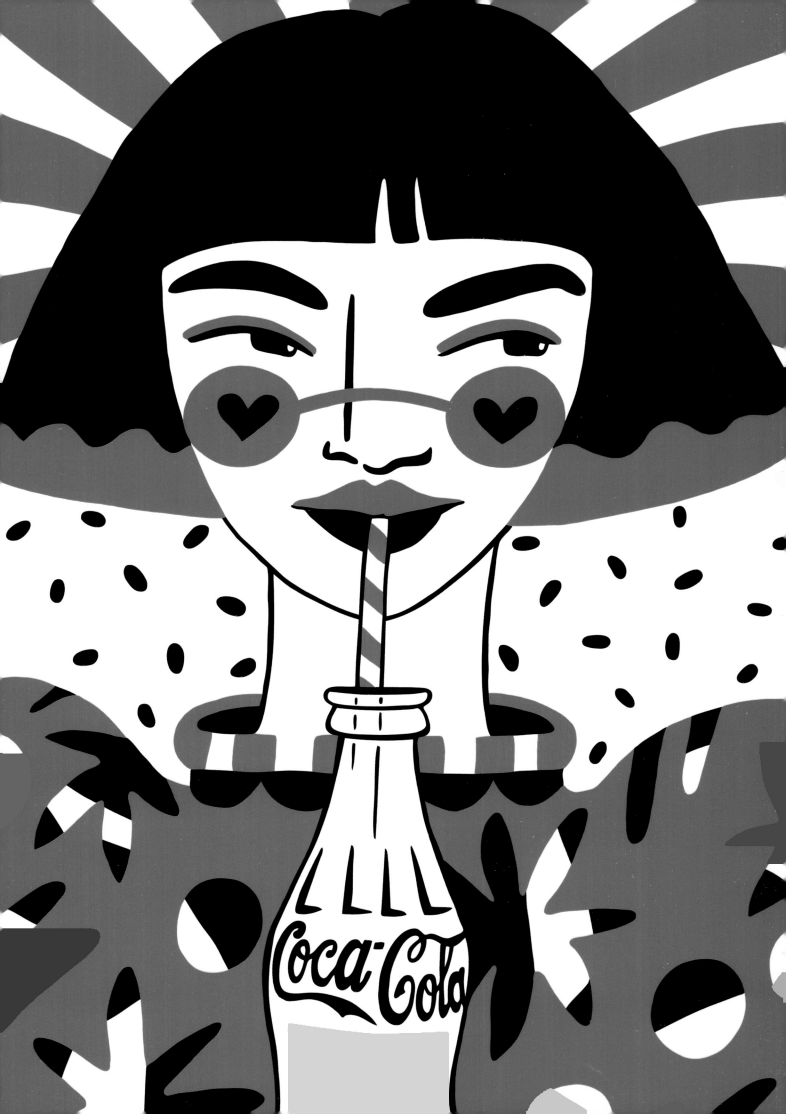

Lynnie Zulu, *Sunrise Babe,* 2014.

Jeff Schaller, *All American,* 2014; encaustic on birch cradleboard, 24 x 24 in. (61 x 61 cm).
Opposite: Lance Wyman, *JOY,* 2014.

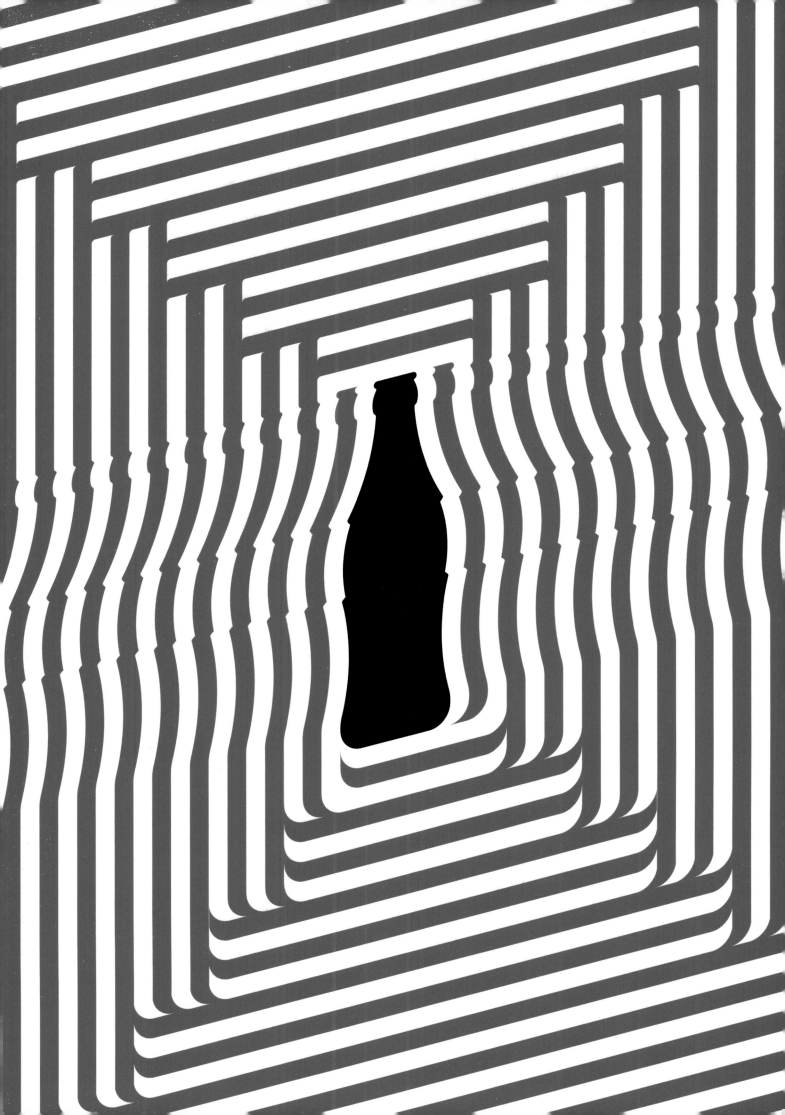

66 What is so iconic about the Coca-Cola bottle is that you can identify it by touch alone. Close your eyes and feel the form in your hands, you don't need to rely on your other senses to know what it is. 99

Noma Bar
Graphic Designer

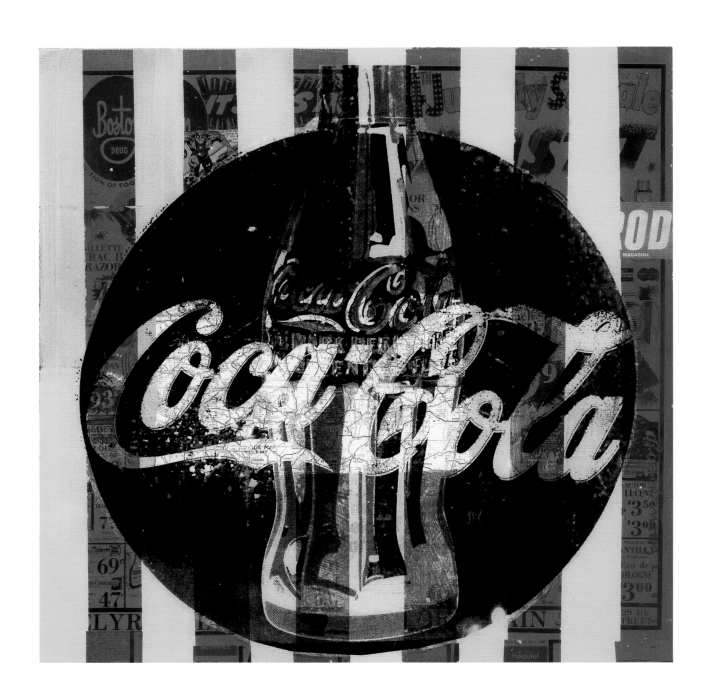

Robert Mars, *Coke Bottle,* 2011; mixed media on panel with epoxy resin, 24 x 24 in. (61 x 61 cm).
Opposite: Robert Mars, *The Most Beautiful,* 2011; mixed media on panel with epoxy resin, 24 x 24 in. (61 x 61 cm).

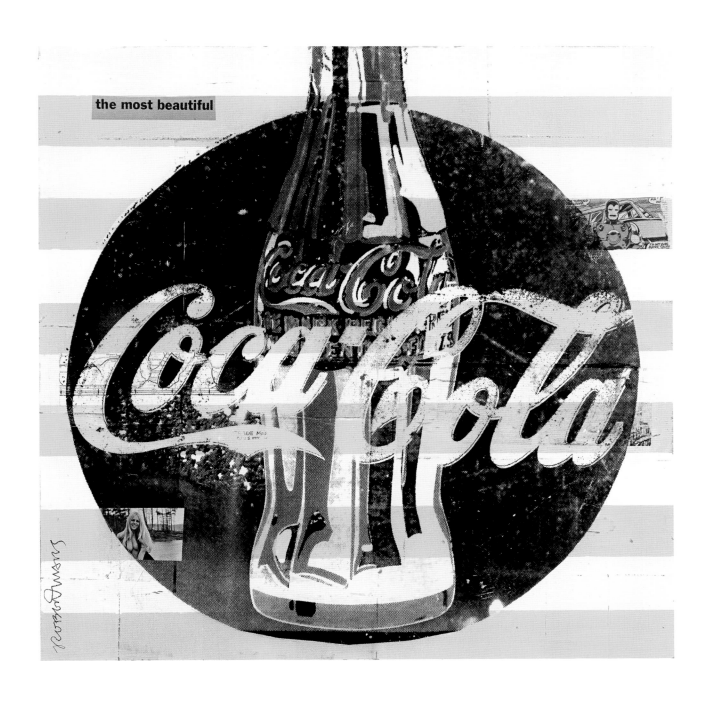

the most beautiful

Following pages, from left: Andrew Sherborne, *Unmistakable,* 2014.
Forpeople, *Loop,* 2014.

109

" It's a very rare thing when a product's shape can become a piece of our culture. I can remember shopping at antique stores when I was a child and being drawn to the old wooden crates filled with the classic Coke bottles. The Coke bottle that I drank out of as a kid is still the same shape as the Coke bottles my own kids drink from today. The memory of Coke goes far beyond its taste: It's also about the shape, the color, the texture. It's a sensory experience. And that memory is timeless. "

David Schwen
Graphic Designer

Brazilian advertising poster, 1948.

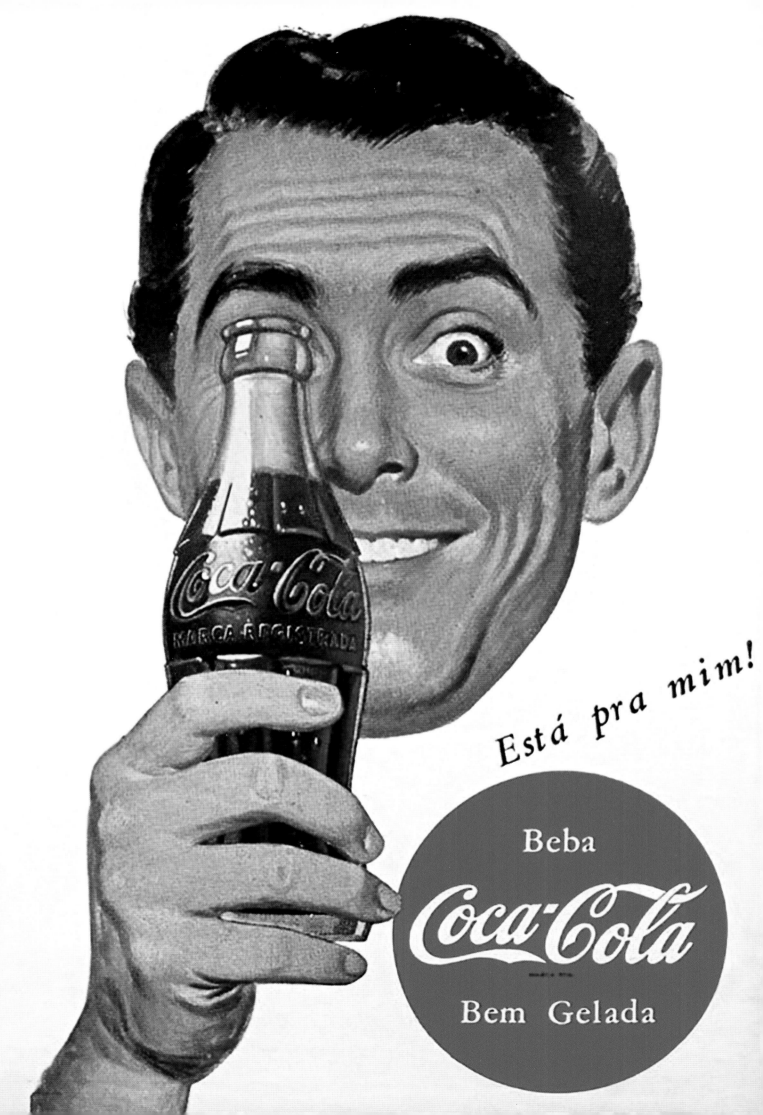

Joseph Beuys, *Bruno Corà-Tee,* 1975; Coca-Cola bottle with herbal tea
in wooden box, edition of 40, Lucio Amelio, Napoli,
11 1/4 x 4 1/2 x 4 1/8 in. (28.6 x 11.3 x 10.5 cm).

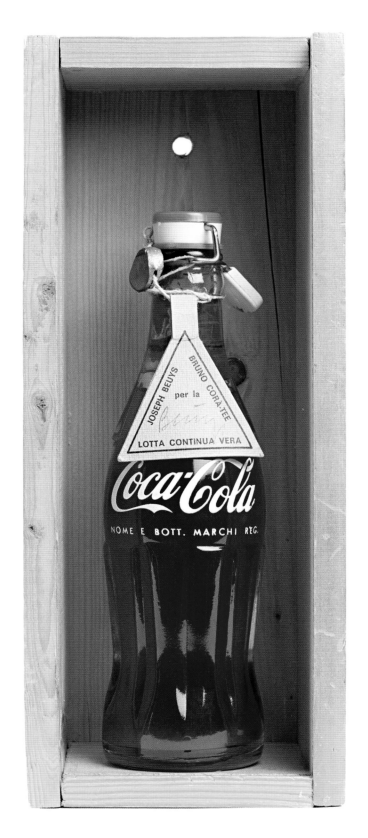

BEUYS
1975
EDIZIONE
LUCIO AMELIO
NAPOLI

"The Coke bottle is a masterpiece of scientific, functional planning. In simpler terms, I would describe the bottle as well thought out, logical, sparing of material and pleasant to look at. The most perfect 'fluid wrapper' of the day and one of the classics in packaging history."

Raymond Loewy
Industrial Designer

Vault49, *Time Warp*, 2014.
Following pages, from left: Paul Meates, Droga5, *100 Years*, 2014.
Robert Rauschenberg, *Coca-Cola Plan,* 1958; combine: pencil on paper,
oil on three Coca-Cola bottles, wood newel cap, and cast metal wings on wood structure,
26 3/4 x 26 x 5 3/8 in. (68 x 66 x 13.7 cm).

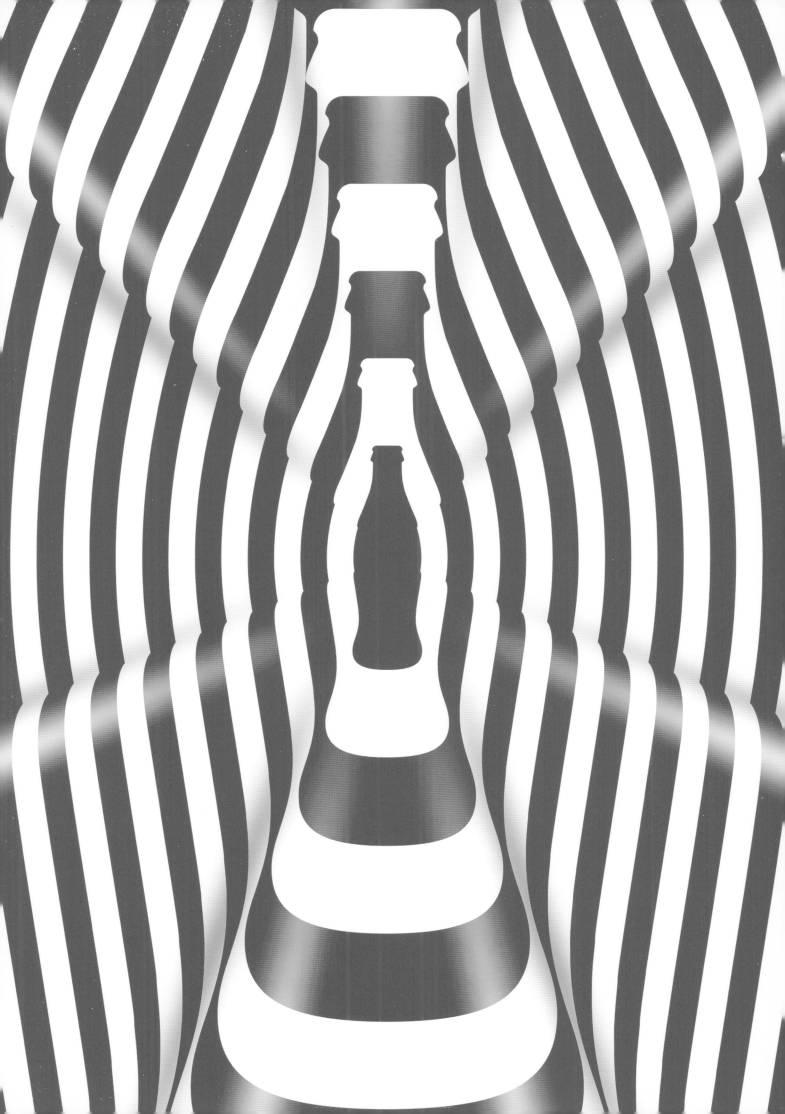

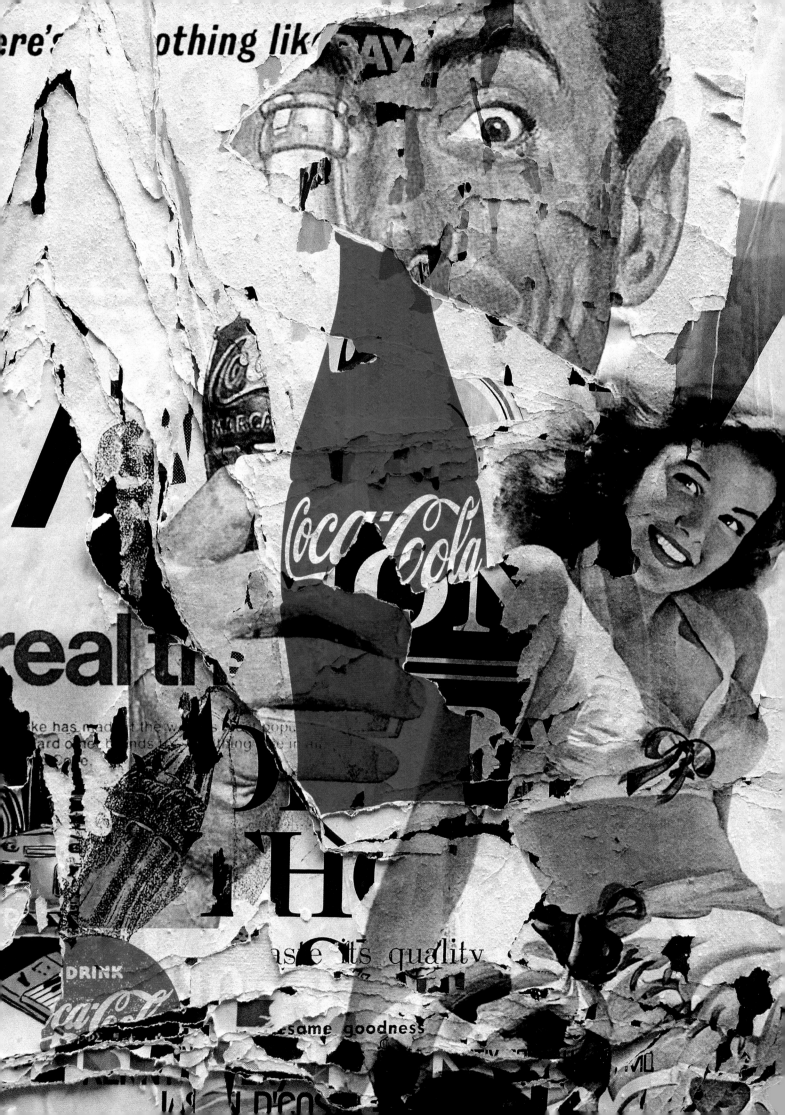

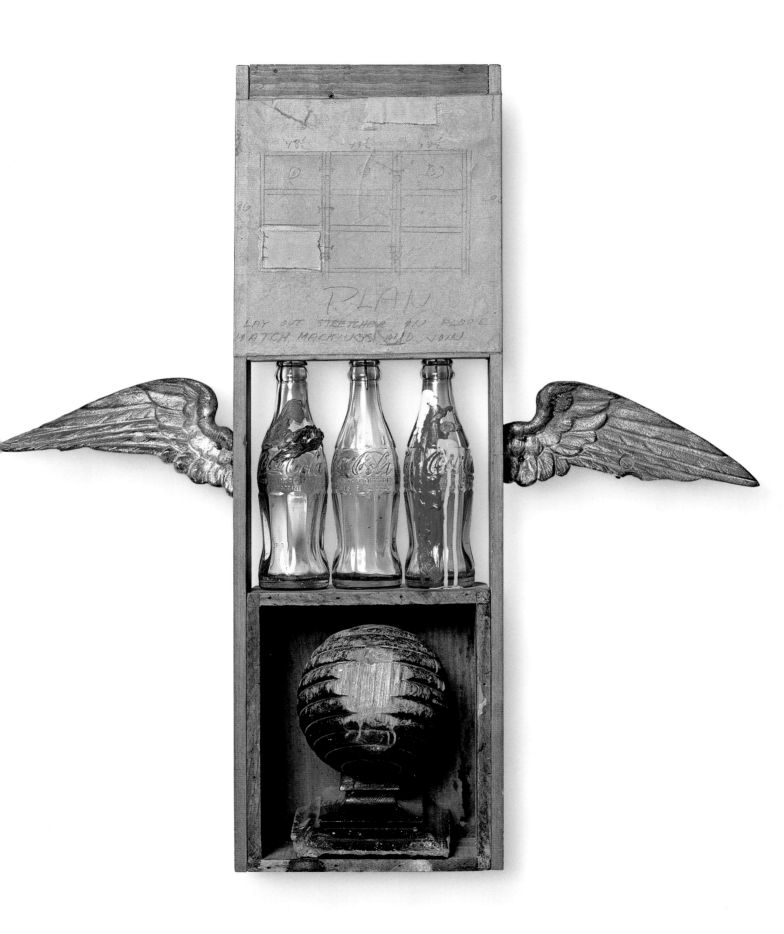

Pakpoom Silaphan, *Frida on Coca-Cola Crates,* 2013;
mixed media on vintage wooden crates with glass bottles, 16 1/2 x 18 1/2 x 11 7/8 in. (41.8 x 47 x 30 cm).
Following pages, from left: Alberto Moreu and Piero Di Biase, Think Work Observe, *Sunshine,* 2014.
Marcelo Joulia, Naco, *Curves of Happiness,* 2014.

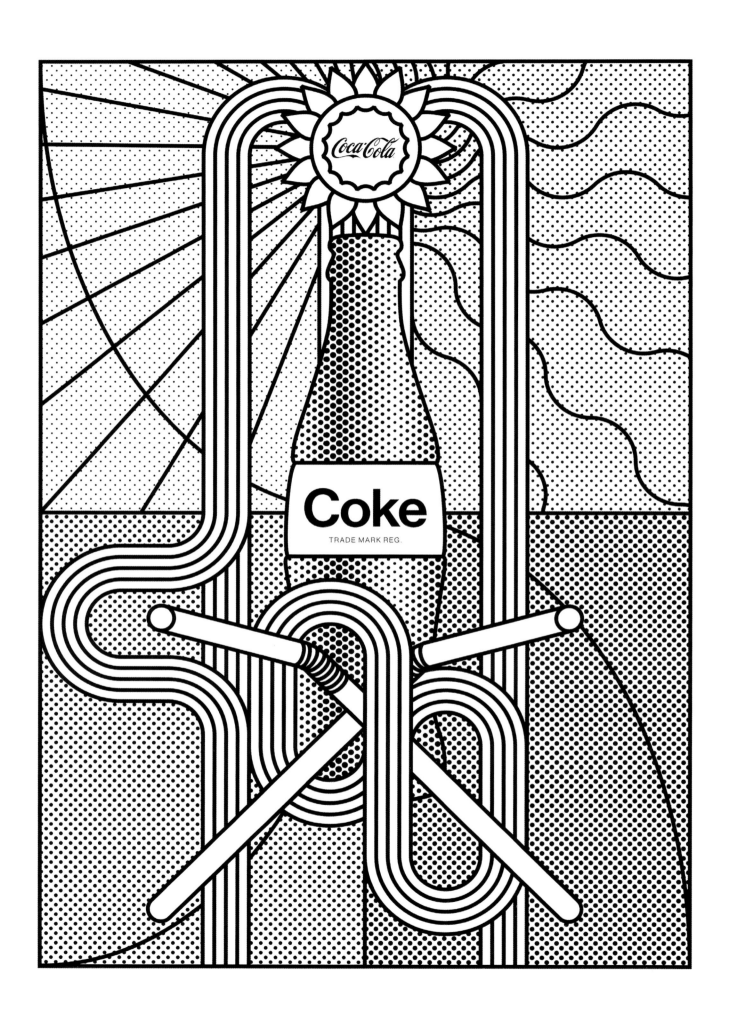

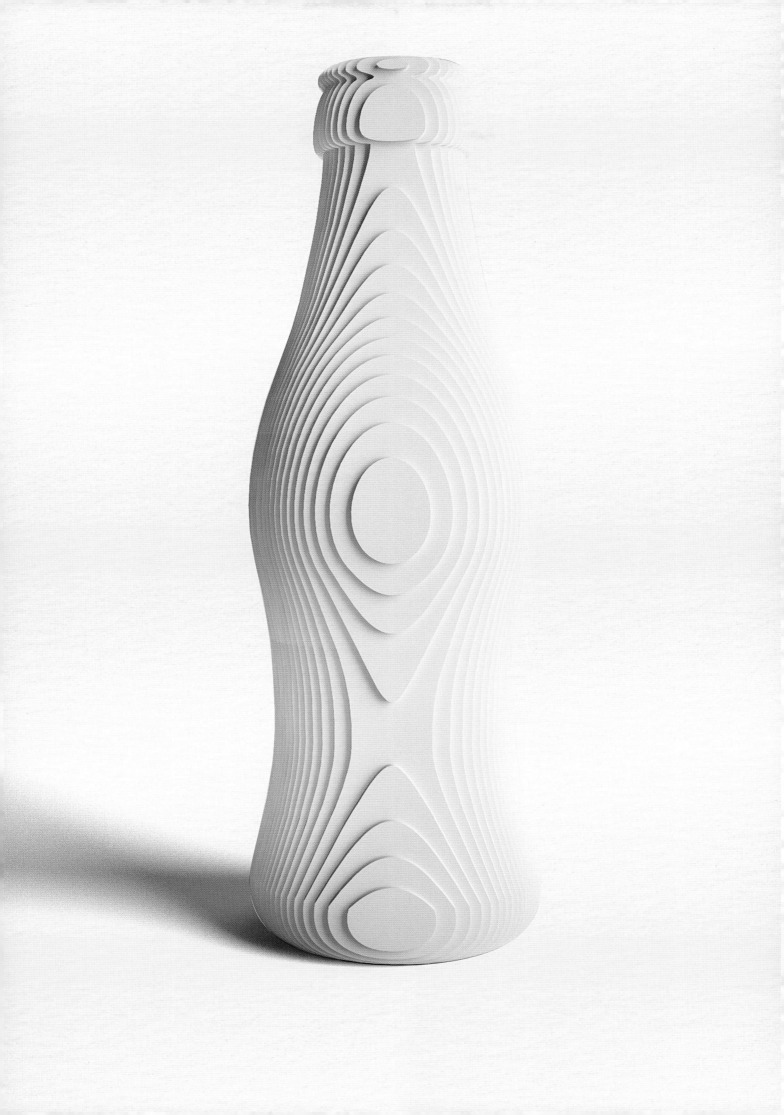

" Voluptuously shaped with soft grooves emphasizing its appeal, the Coca-Cola bottle is a piece of design in itself. Its silhouette is recognizable from any other bottle and stands for its uniqueness. As countries opened their frontiers, this iconic design traveled all around the world as a symbol of innovation, freedom, fashion, and behavioral change inspiring many artists (Andy Warhol, René Goscinny, Jamie Uys), and standing as DNA of the United States to the world. As the product accompanied people in their everyday lives, everyone started to use it in various ways, from consumption to art, decoration, flowerpots, sweet boxes...and it started to become, little by little, a major icon of pop culture. **"**

Ogilvy & Mather Advertising Paris

Ogilvy & Mather Advertising Paris, *Paris' Shape,* 2014.
Following pages: International Coca-Cola bottles, 2014.

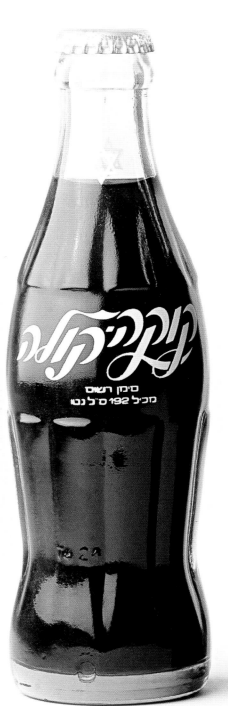
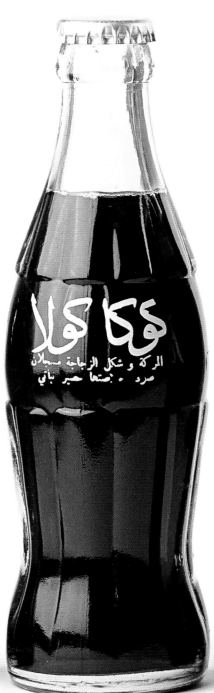
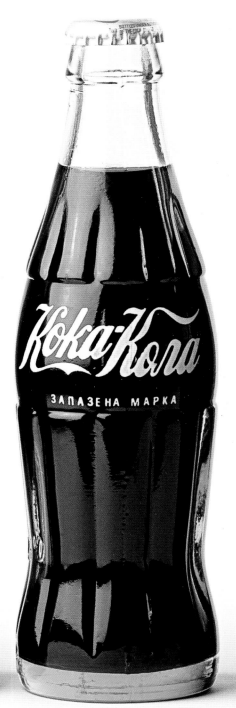

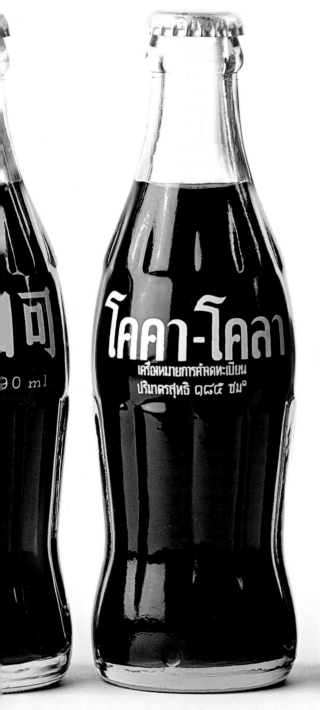

Andy Warhol, *Andy Warhol's Velvet Underground featuring Nico,* 1971;
inside cover art of vinyl album, 12 1/2 x 25 in. (31.75 x 63.5 cm).

THE COCA-COLA BOTTLE

By Ted Ryan

Ironically, one of the world's most iconic shapes came about accidentally. In 1899, two Chattanooga lawyers, Thomas Whitehead and Benjamin Thomas, traveled to Atlanta to negotiate the rights to bottle the Coca-Cola beverage. The soda fountain drink had become increasingly popular and in a mere thirteen years, sales of Coca-Cola grew from an average of nine drinks per day in a small Atlanta-based drugstore to being sold in every state in the country by 1900. The origins of the bottle are rooted in the ingenuity of Whitehead and Thomas, who wanted to capitalize on the popularity of the drink by enabling it to be consumed beyond the four walls of a soda fountain.

Asa Candler, the owner of The Coca-Cola Company, agreed to the deal and sold the pair the bottling rights for only $1. The contract allowed for Whitehead and Thomas to establish The Coca-Cola Bottling Company and proceed to franchise the rights to bottle Coca-Cola in cities across the United States. By 1920, over 1,200 Coca-Cola bottling operations had been established. Sales in both fountain and bottle form continued to increase, and the drink's popularity led to dozens of competitors who imitated the famous trademark of Coca-Cola to deceive the public into buying their drinks.

The bottles used in those days were simple, straight-sided bottles that were typically brown or clear. Brands like Koka-Nola, Ma Coca-Co, Toka-Cola, and even Koke copied or only slightly modified the Spencerian script logo duping consumers into drinking their beverages. The paper labels then used to mark the bottles would often peel off while cooling down in buckets of ice water, so The Coca-Cola Company required that the bottlers emboss the famous Coca-Cola logo onto every bottle. Even then, these competitor bottles created confusion among consumers. Although The Coca-Cola Company began litigation against these infringements, the cases often took years to resolve, and the bottlers were constantly asking for more protection.

By 1912, The Coca-Cola Bottling Company had sent a note all of its members noting that while The Coca-Cola Company had a distinctive logo, they did not have a way to

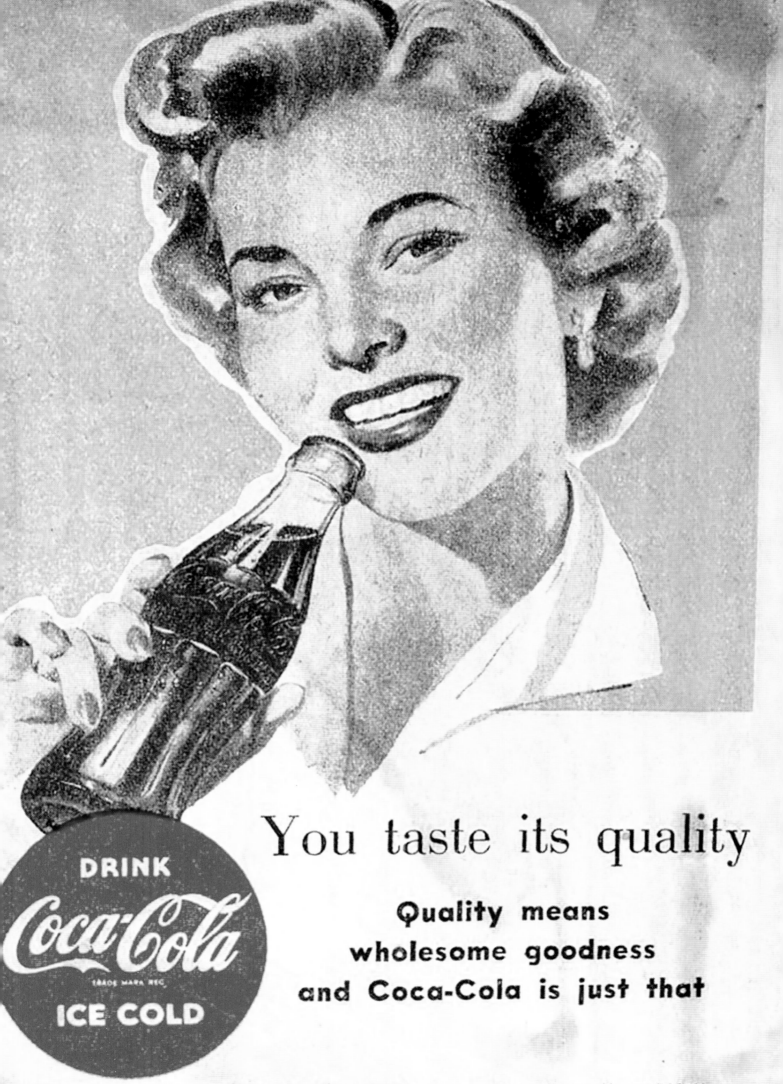

You taste its quality

**Quality means
wholesome goodness
and Coca-Cola is just that**

DRINK
Coca-Cola
TRADE MARK REG.
ICE COLD

THE COCA-COLA COMPANY (Inc. in U.S.A., Liability Limited) SYDNEY.

protect their business. They proposed that the members all join together and develop a "distinctive package" for their product. They worked with Harold Hirsch, the lead attorney for The Coca-Cola Company, who made an impassioned plea for the bottling community to unite behind a distinctive package:

> We are not building Coca-Cola alone for today. We are building Coca-Cola forever, and it is our hope that Coca-Cola will remain the National drink to the end of time. The heads of your companies are doing everything in their power at considerable expense to bring about a bottle that we can adopt and call our own child, and when that bottle is adopted I ask each and every member of this convention to not consider the immediate expense that would be involved with changing your bottle, but to remember this, that in bringing about that bottle, the parent companies are bringing about an establishment of your own rights. You are coming into your own and it is a question of cooperation.

On April 26, 1915, the Trustees of the Coca-Cola Bottling Association voted to spend up to $500 to develop a distinctive bottle for Coca-Cola. Subsequently, eight glass companies across the country were challenged to develop a "bottle so distinct that you would recognize it by feel in the dark or lying broken on the ground." With that simple creative brief, the competition was on.

In Terre Haute, Indiana, the Root Glass Company received the brief and held a meeting to begin to work on their design. The Root team was composed of C.J. and William Root, Alexander Samuelson, Earl Dean and Clyde Edwards. Samuelson, a Swedish immigrant who was the shop foreman, sent Dean and Edwards to the local library to research design possibilities. The pair mistakenly believed that the cocoa pod was one of the ingredients in Coca-Cola's secret formula, so they searched its entry in the 1911 edition of the *Encyclopedia Britannica*. That particular cocoa pod illustration served as the design inspiration they were looking for. With its elongated form and distinct ribs, they had their shape. Dean carefully sketched the now recognizable shape on heavy linen paper and under Samuelson's direction, a few sample bottles were struck.

The Root Glass Company put forth a patent registration under Samuelson's name, which was granted on November 16, 1915. That date was later incorporated into the lettering on the final design of the bottle. It is interesting to note that the patent submission was made without the signature embossed Coca-Cola script lettering. This was done to protect the secrecy of the design—and the ultimate client.

In early 1916, a committee composed of bottlers and company officials met to select the bottle design. The Root version was the clear winner but in an interesting side note, the vote was not unanimous because Arthur Montgomery, the owner of the Atlanta Coca-Cola Bottling Company had seen C.J. Root with the bottle and thus recused himself from the vote. The Coca-Cola Company and the Root Glass Company entered an agreement to have six glass companies across the U.S. use the bottle shape. The contract called for the bottles to be colored "German Green" which was later renamed "Georgia Green" in homage to the home state of The Coca-Cola Company. It also called for the name of the city placing the glass order to be embossed on the bottom of the bottle. These city names entertained consumers for decades and for generations led kids to compare whose bottle was from farther away. The weight of glass was to be no less than 14.5 ounces, which when filled with the 6.5 ounces of Coca-Cola meant each bottle weighed more than a pound!

The Coke bottle has been called many things over the years. One of the more interesting of the nicknames is the "hobbleskirt" bottle. The hobbleskirt was a fashion trend during the 1910s, where the skirt had a very tapered look and was so narrow below the knees that it "hobbled" the wearer. The bottle was also called the "Mae West" bottle after the actress's famous curvaceous figure. The first reference to the bottle as a "contour" occurred in a 1925 French magazine *Le Monde*, which described the Coca-Cola bottle as having a distinctive contour shape. To the general public, the shape is still just "the Coke bottle."

Today, as we celebrate 100 years of the patent of the famous contour-shaped Coca-Cola bottle, it is indeed the perfect shape for all who want to enjoy an ice cold, delicious, and refreshing Coca-Cola.

CHRONOLOGY

100 Years of the Coca-Cola Bottle

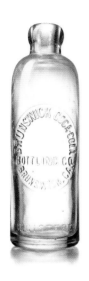 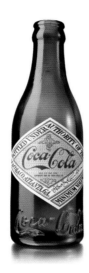 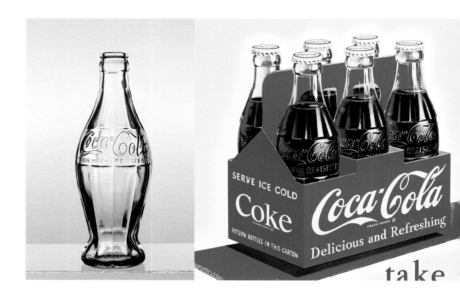

1899

Coca-Cola first bottled under contract in Chattanooga, Tennessee. Coca-Cola President Asa Candler sells the bottling rights for $1. Bottles used at this time are straight-sided Hutchinson bottles with a metal stopper.

1906

Amber-colored and clear straight-sided bottles with an embossed logo are used by bottlers across the U.S. In 1906, a diamond shaped label is added to make the bottle stand out from competitors.

1915

The tremendous success and growth of Coca-Cola encourages competitors to try to imitate Coke by offering bottles with slight variations on the trademarked name and distinctive script logo. The now famous Coca-Cola contour bottle is patented in 1915 by the Root Glass Company of Terre Haute, Indiana. The creative brief given to Root called for a bottle that could be recognized when broken on the ground or by touch in the dark.

1923

With the expanded availability of home refrigeration, the six-pack bottle carrier is developed by the Coca-Cola system to encourage consumers to enjoy the beverage at home.

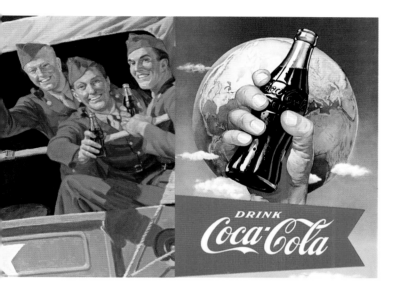

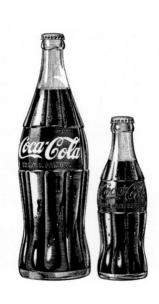

1941

Thousands of men and women are sent overseas. The country, and Coca-Cola, rally behind them. President Robert Woodruff orders that "every man in uniform gets a bottle of Coca-Cola for five cents, wherever he is, and whatever it costs the company." His vision that Coca-Cola be placed within "arm's reach of desire" becomes real—from the mid-1940s until 1960, the number of countries with bottling operations nearly doubles.

1950

Coca-Cola becomes the first commercial product to appear on the cover of *Time* magazine. The appearance solidifies Coca-Cola as an international brand. The magazine originally asks to place long-time Company leader Robert Woodruff's image on the cover, but he refuses, saying the brand is the important thing and Coca-Cola itself should be featured.

1955

Coca-Cola expands its packaging offering from the standard 6.5-ounce contour bottle to include 10-, 12- and 26-ounce contour bottles in the U.S., marking an important step in giving consumers packaging options to meet their needs.

1957

Coca-Cola contour bottles are printed with a white label featuring both trademarks, Coca-Cola and Coke. Previously the trademark Coca-Cola had been blown in glass lettering on the bottle.

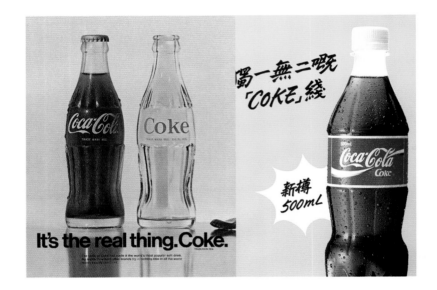

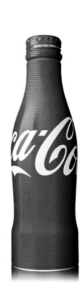

1960

Twelve-ounce aluminum Coca-Cola cans are introduced in the U.S. Early can graphics include an image of the Coca-Cola bottle so customers will recognize it as the same beverage they enjoy from a bottle.

1977

The Coca-Cola bottle is granted registration as a trademark, a designation awarded to few other packages. A previous study showed that less than one percent of Americans could not identifiy a bottle of Coke by shape alone.

1993

The 20-ounce PET contour bottle is introduced. The bottle helps distinguish Coca-Cola from other beverages, just as the glass contour bottle had in 1915.

2008

Coca-Cola is awarded the first ever Design Grand Prix at the prestigious Cannes Lions for the brand's refreshed visual identity and packaging of the aluminum bottle.

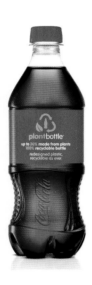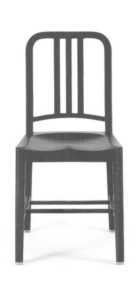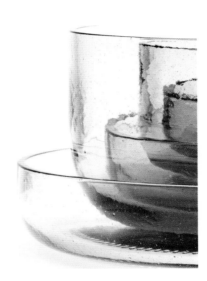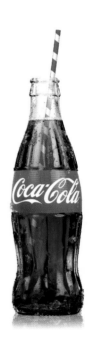

2009

Coca-Cola introduces
the "plant bottle"—100%
recyclable and made with up
to 30% renewable, plant-
based material.

2010

The 111 Navy Chair debuts at
the Salone Internazionale del
Mobile. Through partnership
with Emeco, the iconic Navy
Chair gets a fresh spin, in a new
material. Each chair is made
from 111 PET bottles diverted
from landfills.

2012

Bottleware by Nendo
debuts at Design Tide
Tokyo. The collection of bowls
is made from recycled glass
Coca-Cola bottles which can
no longer be refilled or reused.
The form is inspired by the
base of the iconic bottle.

2015

The Coca-Cola bottle
turns 100.

"The perfect liquid wrapper."
—Raymond Loewy

THE MASHUP PROJECT 2015

We invited artists and designers from around the world to create a celebratory poster imagining the next 100 years of the Coca-Cola bottle experience.

Taking inspiration from vintage advertisements and bottle imagery from the Coca-Cola Archives, each creative was asked to design an A1 poster using only Coke Red, black, and white.

The resulting posters are as varied and unique as their creators—each an expression of individuality, linked together by the Coca-Cola bottle, an enduring icon of universal happiness.

To all those who contributed so generously with their time, passion, love, and art, we'd like to raise an ice cold Coca-Cola to you.

Coca-Cola Design

Mashup Project Participants:

Adam Derry, ADBD; Margaux Carpentier, Bradley Jay, Billie Jean, Sara Mulvanny, Giordano Poloni, Alice Stevenson, and Jess Wilson, Agency Rush; Yoni Alter; Am I Collective; Brett Wickens, Ammunition Group; Anonymous; David Carlino and Daghan Perker, Anthem New York; ANTI; Stefan Kjartansson, Armchair Media; Ivan Khmelevsky, The Bakery; Noma Bar; Believe in; Craighton Berman; Marcos Bernardes; BGO: Bonafide Guests Only; Tim Beard, Jonathon Jeffrey, and Mason Wells, Bibliothèque Design; Camille Dorival, Dag Laska, and Ludvig Bruneau Rossow, Bleed; Daniel Andersson, Brand Union; Paula Castro, Breed; Neville Brody; Kyle Brooks; BVD; Jovaney A. Hollingsworth and Charles S. Anderson, Charles S. Anderson Design; Stanley Chow; CINCO; CMA Design; Rapha Abreu, Matt Allen, Coley Porter Bell, Tom Farrell, Julio Ferro, Sarah Kim, Megan Libby, Hidetaka Matsunaga, Sakiko Nagahara, Deklah Polansky, James Sommerville, Blake Tannery, and Ashley Tipton, Coca-Cola Design; Brian Collins and Thomas Wilder, COLLINS; Conran Partners; Jimi Crayon; Crispin Finn; John J. Custer; Holly Dennis; Tony Di Spigna; Dress Code; David Droga, Jessica Faller, Rich Greco, Ben Grube, Conor Hagan, Christina Hillman, Devon Hong, J.J. Kraft, Paul Meates, Jimmy Morrissey, and Martins Zelcs, Droga5; DRx Romanelli (Darren Romanelli); David Schwen, Dschwen LLC; Duane Dalton; Duffy & Partners; Finished Art; Forpeople; Freytag Anderson; Guillermo Bagnato and Guillermo Tragant, Furia; Julene Harrison; Harry Allen Design; Hey; HI(NY); Idea is Everything; ILOVEDUST; Jake Johnstone; Kasper-Florio; Matthew Kenyon; Tholön Kunst; La Boca; Natalia Kowaleczko and Alisa Wolfson, Leo Burnett Design; Javier Rodriguez Garcia, Lobulo Design; LOOP; Richard Loveless; Lundgren + Lindqvist; Maddison Graphic; David Azurdia and Ben Christie, Magpie Studio; Jonathan Mak; Tim Marrs; Mark Bloom, Mash Creative; Gary Todd, McCann; Thomas Meyerhoffer; Midday; Brent Couchman, Moniker; Christian Montenegro; Philip Morgan; Thierry Guetta, Mr. Brainwash; Marcelo Joulia, Naco; Neiko Ng; Esra Büyükdoganay and Stephan Vogel, Ogilvy & Mather; Ogilvy & Mather Advertising Paris; Ray Oranges; Alejandro Paul; Phunk Studio; Platform, Inc.; POGO, Creative Co.; Josie Portillo; Ryan Gillett, Puck Collective; Carman Pulliam; Andrew Eaton, Roberta Fara, Aidan Giuttari, Emily Moore, Ilya Yudanov, R/GA; Stu Ross; Harriet Russell; Sawdust; Script and Seal; Andrew Sherborne; Son&Sons; Hayato Kohama, SPECIAL PRODUCT DESIGN; Stag&Hare; Stockholm Design Lab; Studio MPL; Taxi Studio and Sam Hadley; Upendo Taylor; Piero Di Biase and Alberto Moreu, Think Work Observe; Jeff Myers, This Is Red; Trollbäck + Company; Nicole Jordan, Sarah Moffat, Brian Steele, Drew Stocker, and David Turner, Turner Duckworth; Si Billam, UNIT; Vault49; Eve Warren; Toby Warren; Lance Wyman; Lynnie Zulu.

Tom Farrell, Coca-Cola Design, *Happiness Is in Our Hands*, 2014.

ACKNOWLEDGMENTS

Acknowledgment and gratitude go to the hundreds of thousands of Coca-Cola System employees who have built the business over the past 128 years, and to the billions of consumers around the world who have made the Coca-Cola brand the icon it is today. Special thanks to the Coca-Cola Archive team for their expertise and support and at Assouline Publishing to: Martine and Prosper Assouline, Aurora Bell, Camille Dubois, Eduard De Lange, Hannah Hayden, Esther Kremer, Stéphanie Labeille, and Cécilia Maurin, Jacqueline Poirier, and Rick Willett.

Assouline would like to thank the following individuals for their invaluable assistance: Joshua Condon; Sofia D. Bakis, Allentown Art Museum, Pennsylvania; Samo Gale, The Andy Warhol Foundation for the Visual Arts, Inc., New York; Greg Burchard, The Andy Warhol Museum, Pittsburgh; Jennifer Belt and Peter Rohowsky, Art Resource; M. Fernanda Meza, Artists Rights Society; Wendy Zieger, Bridgeman Images; Julia Morris, DTR Modern Gallery, New York; Beverly Finster Guinn; Todd Ford; Andra Norris, Gallerie Citi, Burlingame, CA; Dr. Leonhard Emmerling, Goethe Institut, Munich; Barbara Gogan; Taylor Livingston and Jennifer Vanoni, The Hopper Art Trust; Kim Frohsin, Kim Frohsin Fine Art; Luc Alexis Chasleries, L.A.C. Retouching; Gladys-Katherina Hernando, The Museum of Contemporary Art, Los Angeles; Orson Peellaert, The Estate of Guy Peellaert, Paris; Jeff Schaller, Pinkcow Studio; Sally Tharp, Sally Tharp Fine Art; Thomas E. Scanlin; Pakpoom Silaphan; Skot Foreman, Skot Foreman Fine Art; Charlotte Van Dercook, Sotheby's Contemporary Art, New York; Diana Vachier, Steve Kaufman Art Licensing, LLC; Anna Chovanec, Lucy Mulroney and S. Ann Skiold, Syracuse University Library, New York; Mollie Bernstein, VAGA; Svenja Eilers, VG Bild-Kunst, Bonn, Germany; Susanne Schmid and Franziska Schmidt, Villa Grisebach Auktionen GmbH, Berlin; An Jo and Gabriel Toso, Whitford Fine Art, London; Emma Lott, Whitney Museum of American Art, New York.

ABOUT THE AUTHORS

Stephen Bayley is an author, critic, columnist, consultant, broadcaster, debater, and curator. His best-selling books and award-winning journalism have, over the past thirty years, changed the way the world thinks about design. He is a contributing editor to *GQ* and *Management Today* and writes for a wide range of international publications. His most recent book is *Ugly: The Aesthetics Of Everything* (2012).

As Director of Heritage Communications for The Coca-Cola Company, Ted Ryan oversees an extensive collection of physical and digital artifacts showcasing the rich history of Coca-Cola. He led the program to restore, digitize, and catalog over 25,000 historical ads created by The Coca-Cola Company for donation to the Library of Congress, and his contributions to the World of Coca-Cola have included curating the "Pop Culture" gallery with an extensive Andy Warhol exhibit.

James Sommerville has been VP of Global Design at The Coca-Cola Company since 2013. In 2006, his creative agency, ATTIK, led the redesign of Coke's brand identity, an initiative tagged "revival of an icon." He went on to design visual identity systems for Coca-Cola's key global platforms, the 2010 FIFA World Cup South Africa™, 2010 London Olympics, and 2014 FIFA World Cup Brasil™.

CREDITS

Front cover: © The Coca-Cola Company. Back cover: Furia © The Coca-Cola Company. Endpapers: all images © The Coca-Cola Company, artists listed by row, from left; front, row 1: Deklah Polansky/Coca-Cola Design, Brent Couchman, Moniker, Harry Allen Design, Matt Allen/Coca-Cola Design, DRx Romanelli, TIM MARRS, Ivan Khmelevsky/The Bakery, CMA Design, Upendo Taylor, Forpeople; front, row 2: Lance Wyman, Stockholm Design Lab, Tom Farrell/Coca-Cola Design, Rapha Abreu/Coca-Cola Design, James Sommerville/Coca-Cola Design, Deklah Polansky/Coca-Cola Design, Ludvig Bruneau Rossow/Bleed, Furia, David Schwen/Dschwen LLC, Thomas Wilder/COLLINS; front, row 3: James Sommerville/Coca-Cola Design, Noma Bar, Ashley Tipton/Coca-Cola Design, Tom Farrell/Coca-Cola Design, Stanley Chow, Sakiko Nagahara/Coca-Cola Design, Sawdust, Matthew Kenyon, HI(NY), Finished Art; front, row 4: Josie Portillo, Son&Sons, Emily Moore/R/GA, Crispin Finn, Megan Libby/Coca-Cola Design, Script and Seal, Finished Art, Forpeople, Deklah Polansky/Coca-Cola Design, Jess Wilson/Agency Rush; front, row 5: Daghan Perker/Anthem New York, Hey, Mark Bloom/Mash Creative, Jimmy Morrissey/Droga5, David Azurdia and Ben Christie/Magpie Studio, Roberta Fara/Coca-Cola Design, Si Billam/Unit, Tom Farrell/Coca-Cola Design, Ogilvy & Mather Advertising Paris, Neville Brody; back, row 1: Andrew Eaton/R/GA, Stefan Kjartansson/Armchair Media, Alberto Moreu and Piero Di Biase/Think Work Observe, CINCO, David Azurdia and Ben Christie/Magpie Studio, La Boca, Ogilvy & Mather, Vault49, POGO/Creative Co., Marcos Bernardes; back, row 2: CMA Design, Sarah Kim/Coca-Cola Design, Andrew Sherborne, Christian Montenegro, Finished Art, Julio Ferro/Coca-Cola Design, Anonymous, Turner Duckworth, Craighton Berman, Jovaney A. Hollingsworth/Charles S. Anderson Design; back, row 3: Conor Hagan/Droga5, Eve Warren, Midday, Finished Art, Nicole Jordan and David Turner and Sarah Moffat/Turner Duckworth, Ilya Yudanov/R/GA, BVD, Marcelo Joulia/Naco, Hidetake Matsunaga, Kyle Brooks; back, row 4: Natalia Kowaleczko & Alisa Wolfson/Leo Burnett Design, Christina Hillman/Droga5, Lundgren + Lindqvist, Platform/Inc., ANTI, Jonathan Mak, Maddison Graphic, Matt Allen/Coca-Cola Design, LOOP, ILOVEDUST; back, row 5: Philip Morgan, Mr. Brainwash, Aidan Giuttari/R/GA, Ryan Gillett/Puck Collective, John J. Custer, Lynnie Zulu, Neiko Ng, Yoni Alter, Paul Meates/Droga5, Conran and Partners. Interior: all images © The Coca-Cola Company, except for the following: page 13: © 2015 The Andy Warhol Foundation for the Visual Arts, Inc./Artists Rights Society (ARS), New York, image © Whitney Museum of American Art, New York; pages 18–19, 43, 121: © Pakpoom Silaphan; page 20: © Sally Tharp, image courtesy Parker Smith Photography; page 24: © Robert Mars, image courtesy Parker Smith Photography; page 26: © Whitford Fine Art, London, image courtesy Parker Smith Photography; page 27: © Steve Kaufman Art Licensing, LLC, image courtesy Parker Smith Photography; pages 32–33, 74–75, 126–127, 134 (1915), 135 (1955), 136 (1960): archival images courtesy Parker Smith Photography; pages 37, 86, 88–89, 108–109: © Robert Mars, images © Cary Whittier, courtesy DTR Modern Galleries; page 39: © 2015 The Andy Warhol Foundation for the Visual Arts, Inc./Artists Rights Society (ARS), New York, image courtesy Sotheby's, New York; page 45: © James Rosenquist/Licensed by VAGA, New York, NY, image © Christie's images/Bridgeman Images; page 50: © Thomas E. Scanlin Collection, image courtesy Parker Smith Photography; page 57: © Estate of Tom Wesselmann/Licensed by VAGA, New York, NY, image © Smithsonian American Art Museum, Washington, DC/Art Resource, NY; page 62: © Peter Blake, all rights reserved, DACS/Artists Rights Society (ARS), New York 2015; page 67: © Todd Ford, image courtesy Parker Smith Photography; pages 71–73: © Kim Frohsin, images courtesy Parker Smith Photography; page 81: © 2015 Artists Rights Society (ARS), New York/VG Bild Kunst, Bonn, image courtesy Villa Grisebach Auktionen GmbH, Berlin; page 93: Guy Peellaert © The Estate of Guy Peellaert, all rights reserved; page 94: © Marisol Escobar/Licensed by VAGA, New York, NY, image © The Museum of Modern Art/Licensed by SCALA/Art Resource, NY; page 104: © Jeff Schaller, image courtesy Parker Smith Photography; page 115: © 2015 Artists Rights Society (ARS), New York/VG Bild-Kunst, Bonn, images courtesy Parker Smith Photography; page 119: © Robert Rauschenberg Foundation/Licensed by VAGA, New York, NY; pages 128–129: © 2015 The Andy Warhol Foundation for the Visual Arts, Inc./Artists Rights Society (ARS), New York, image courtesy Parker Smith Photography.